IMAGES
of America

ASHTABULA

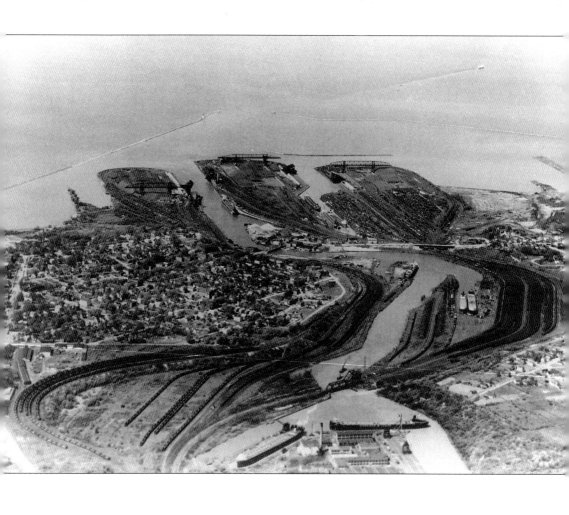

To my wife, Pamela, who suggested this book;
and in memory of Tellervo Sebell, Ashtabula musician and historian.

IMAGES
of America

ASHTABULA

David Borsvold
with
The Ashtabula Great Lakes Marine
and Coast Guard Memorial Museum

ARCADIA

Published by Arcadia Publishing
Charleston SC, Chicago IL, Portsmouth NH, San Francisco CA

Printed in Great Britain

Library of Congress Catalog Card Number: 2002116264

For all general information contact Arcadia Publishing at:
Telephone 843-853-2070
Fax 843-853-0044
E-mail sales@arcadiapublishing.com
For customer service and orders:
Toll-Free 1-888-313-2665

Visit us on the internet at http://www.arcadiapublishing.com

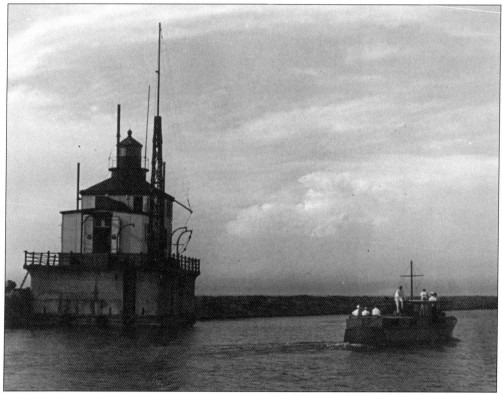

ASHTABULA LIGHTHOUSE IN 1940. (Herbert Satterlee photo, courtesy of Ashtabula County District Library.)

CONTENTS

ACKNOWLEDGMENTS

This book would not have been possible without the enthusiasm, cooperation and fact-checking of a group of highly dedicated volunteers at the Ashtabula Great Lakes Marine and Coast Guard Memorial Museum. Director Betty Carnegie exhibited an amazing memory and eye for detail; Anne and Bob Frisbie opened the Museum after it had closed for the season, and did everything possible to facilitate my research and comfort during several visits; Ray and Doree Petros offered their marvelous photo archive; Dale Olin, a former Hulett electrician and a fine storyteller, was spot-on in clarifying fine details of harbor operations and equipment; and Nancy Arnold assisted in photo identification. Their review of the manuscript was essential for accuracy, and any oversights or omissions are mine. Those interested in planning a visit to the Marine Museum should call (440) 964-6847.

The following organizations and people, while having no editorial role or responsibility, were especially generous with their time and resources:

Cleveland State University Library: William C. Barrow, Special Collections Librarian.
Harbor-Topky Memorial Library: Luanne (Mrs. Karl) Meinhardt, Janice Miggo, Jamie Moore, Christie Partridge, and Sandra Williams.
Hubbard House: Charlotte Lehto, Paula Westcott DeMichele, and Daisy Baskerville.
Ashtabula County District Library: Doug Anderson and Tammy Hiltz.
Blakeslee Log Cabin: Jim Stevenson.
Conneaut Historical Railroad Museum: Robert Leach.

I would also like to note the important contributions of Carl Anderson, Carl Bissell, Pamela Lee Gray, Lois Helman, Ron Morse, Jane Moses, Georgia Patriarca, Eleanor Stevenson, Lawson Stevenson, Ross Tittle, Frank Vaccariello, and Terry White.

INTRODUCTION

Ashtabula, Ohio, once one of the nation's busiest ports, has a unique character and civic identity, yet its recent history has a great deal in common with that of many other cities around the United States. The decades of its industrial height were followed by a sudden and precipitous decline, a period of economic difficulties, and the beginnings of a renaissance built upon the recognition that future opportunities for growth are tied in part to the area's redevelopment as a tourist and recreational destination.

The city is scenically located at the mouth of the Ashtabula River along the shore of Lake Erie, in Ashtabula County, the largest and northeastern-most county in Ohio. Its rare and unusual name comes from a Seneca Indian word meaning "fish." The county is an interesting mix of heavy industrial areas and some of the most beautiful forested rolling hills in the Midwest.

A variety of Native American nations including the Seneca, Iroquois, and Algonquin inhabited the area until white settlers began arriving around 1800 to occupy that part of the former Connecticut Western Reserve—a territory rich in high-grade timber, fertile soil, bituminous coal, quality sandstone, maple trees (whose syrup rivaled any in New England), and plentiful game. Lake Erie created a unique climate, with winters which dumped several feet of lake-effect snow, and breezy, humid summer weather which was perfect for growing fruit trees and grapes. These seasonal trends have given rise to the ski areas and wineries which are Ashtabula County tourist attractions today.

Ashtabula was founded in 1803, although formal incorporation would not come until 1891. During its early decades Ashtabula became a center of anti-slavery sentiment, and later served as a northern terminus of the fabled Underground Railroad. Escaping slaves would hide in several local houses before taking ships to Canada with the help of Lake Captains who were friendly to the cause. This tradition, a source of pride to Ashtabula's citizens, is celebrated today with the Hubbard House Museum and an annual pilgrimage to several other local historic houses.

Ashtabula has had its share of nationally-known natives—including Don Novello, who played Father Guido Sarducci on "Saturday Night Live"—but two of them stand out. William Dean Howells (1837–1920), the son of the owner of the Ashtabula *Sentinel*, began his writing career in the office of that newspaper. He would go on to serve as editor of the *Atlantic Monthly*. Publishing the likes of Henry James and Mark Twain, he was a powerful literary tastemaker, and was elected to be the first president of the American Academy of Arts and Letters. Lawyer Clarence Darrow (1857–1938) was raised in rural Ashtabula County and served as Ashtabula City Solicitor in 1885, long before he became famous for nationally-known cases such as the "Scopes Monkey Trial."

The presence of a navigable river and harbor had initiated industrial development in Ashtabula in the late 1830s, but the city's most important historical moment was the first permanent linking of the Harbor to a railroad line in 1873, making vital connections with freight schooners and soon drawing immigrant labor from Ireland, Sweden, Italy, and Finland. Ashtabula Harbor, one of Ohio's nine "deep-draft" ports—now maintained by the U.S. Army Corps of Engineers to a depth of 28 feet to accommodate the largest boats—became an important gateway for a unique reciprocal traffic: iron ore coming in from Duluth and (since 1959) Quebec, bound for the blast furnaces of Pittsburgh, Wheeling, and Youngstown; and outbound Appalachian coal. This activity would reach its climax in mid-century. Three large railroads served the city at its industrial peak, and employed many local residents.

Ashtabula has had a long association with the U.S. Coast Guard, the first lighthouse having been established in its harbor in 1835. The Coast Guard was gradually consolidated from four existing agencies: the U.S. Lighthouse Service, which maintained over 100 Great Lakes lights; the U.S. Revenue Cutter Service which fought against smuggling and assumed lifesaving duties; the U.S. Life-Saving Service which undertook small-boat missions to rescue people shipwrecked close to shore; and the inspection, investigation, and regulatory body known as the Steamboat Inspection Service. Near the Lighthouse today is the Ashtabula Great Lakes Marine and Coast Guard Memorial Museum, a nationally-known attraction and resource for Lakes scholars. This book has been written in cooperation with a special group of people who work very hard to maintain and operate this fascinating museum. The photos which they have generously lent are only a small part of a splendid collection which also includes sizable artifacts, scratchbuilt models, large portraits, and attractive displays. These are impossible to encapsulate in a book and must be seen in person to be appreciated.

This photographic history of Ashtabula covers mainly the period from the beginning of the industrial boom in the 1870s to the present day. Its focus is upon the City and the Township of Ashtabula, not the entire county (whose magnificent covered bridges and autumn color have been beautifully captured in recent photographic books by Dr. Parminder Singh). In these images, many never before seen in print, we glimpse the life of a proud city in its heyday, and the overcoming of anxious years of economic decline with a new resolve and confidence on the eve of a Bicentennial celebration in the new millennium.

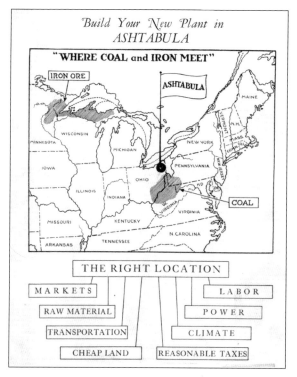

"THE BEST LOCATION IN THE NATION." A 1928 Chamber of Commerce brochure perfectly illustrates the Harbor's advantageous location for bringing ore in and coal out via ships, docks and trains. (Courtesy of Harbor-Topky Memorial Library.)

One

THE HARBOR

On July 11, 1873, the schooner *Emma Maise* arrived at Ashtabula Harbor to connect with the newly-built Pittsburgh, Youngstown, and Ashtabula Railroad line, bearing Ashtabula's first load of Lake Superior iron ore. From that point on, Ashtabula's economic destiny was clear. Harbor improvements, railroad connections and the growth of a vast industrial complex near the Ashtabula River would create an area of booming commerce and put the city on the map.

The 1950s would be the high point of Great Lakes shipping and railroading. In that era, there were several Class I railroads serving the state of Ohio: the Baltimore & Ohio, the Erie, the Nickel Plate, the Bessemer & Lake Erie, and the Chesapeake & Ohio each had separate Lake Erie ports. In Ashtabula, the Pennsylvania Railroad and the New York Central ran rival dock operations on opposite sides of the Harbor, and even the Canadian National had a presence of sorts there until 1958, via a joint carferry operation with the Pennsy that sent freight cars (mostly coal hoppers) to Port Burwell, Ontario.

Feeling an economic pinch, the eastern U.S. railroads began a series of mergers in the 1960s. If a shipper now wished to move a load of coal from Kentucky to Detroit, or from southwestern Pennsylvania to Buffalo, it could do so directly via a single railroad, bypassing the ships. Redundant rail routes were abandoned and the handwriting was on the wall: layoffs and job eliminations on the docks, the boats and the trains would cut out the hearts of the once-flourishing lakefront harbors.

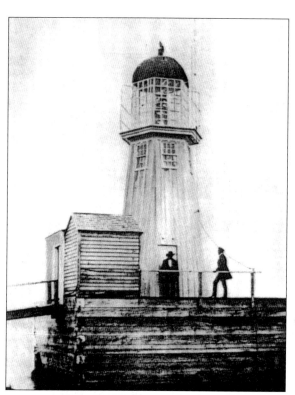

THE FIRST LIGHTHOUSE IN ASHTABULA HARBOR, BUILT IN 1835. (Petros Collection.)

THE ASHTABULA RIVER IN 1874. The piles of lumber are for schooners yet to be built. Ashtabula would be home to a thriving shipbuilding industry until the 1960s. (Courtesy of Ashtabula Marine Museum.)

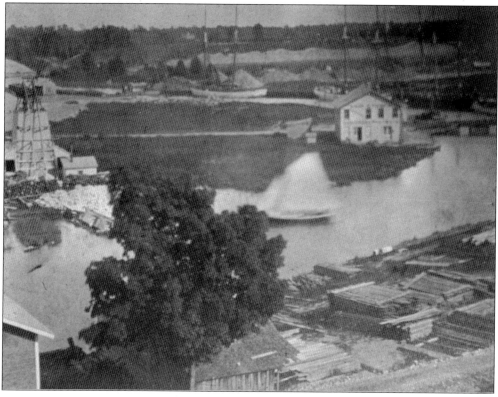

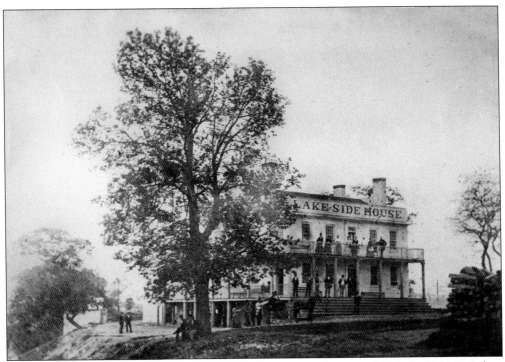

LAKESIDE HOUSE, DATING FROM 1844. This was a rest spot frequented by Lake Captains when their boats were being loaded or unloaded. (Courtesy of Ashtabula Marine Museum.)

THE HARBOR IN THE SCHOONER ERA. (Petros Collection.)

A PRE-1880 VIEW OF THE SOUTH END OF ASHTABULA HARBOR. Although the railroad era in the Harbor is young, considerable industrialization is already underway. (Courtesy of Ashtabula Marine Museum.)

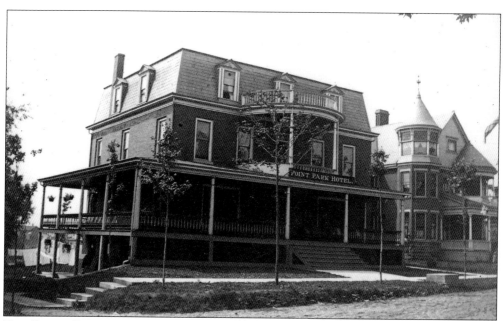

THE POINT PARK HOTEL ON WALNUT BOULEVARD. Located across the street from the present-day site of the Marine Museum, the hotel was the successor to Lakeside House on this spot. Guests had a splendid view of the Harbor from the top of the hill, as did the wife of Captain Myers, who kept watch for incoming boats from the turret of the house at right. The house still stands. (Courtesy of Ashtabula Marine Museum.)

THE CANADIAN SCHOONER ST. ANDREW ON THE RIVERBANK DURING THE FLOOD OF 1878. Great Lakes floods can be caused by two related conditions. In a "storm surge" (or "wind set-up"), sustained straight-line high winds pile the water up at one end of the lake and drain it from the other end. An effect that sometimes follows is called the "seiche." When severe winds abruptly die down or the barometric pressure changes quickly, the water level can seesaw in a pendulum-like motion for days afterward, particularly in Lake Erie, the shallowest of the Great Lakes. (Courtesy of Ashtabula Marine Museum.)

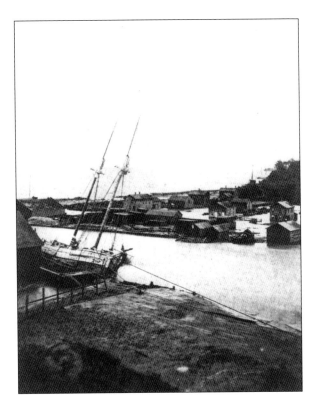

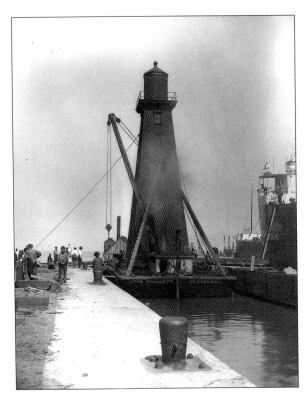

ASHTABULA HARBOR'S SECOND LIGHTHOUSE. This light served the Harbor from 1876–1905. Here, amid a refurbishing of the docks, the light is being removed on the *John Drackett* barge out of Cleveland. Its replacement can be seen in the far distance, over the tops of the men's heads at left. (Courtesy of Ashtabula Marine Museum.)

13

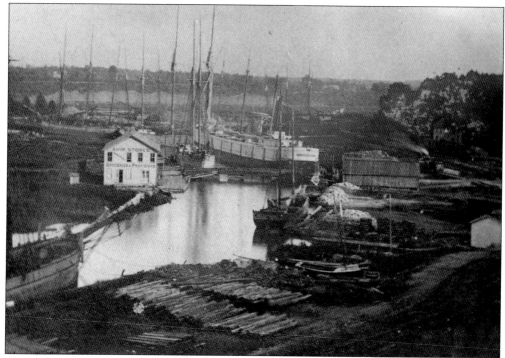

ASHTABULA RIVER IN THE 1870S. In a photograph taken at Point Park looking to the southeast, an early supply store stands alongside a river choked with schooners. The Pontoon Bridge is seen to the right of the store. (Courtesy of Ashtabula Marine Museum.)

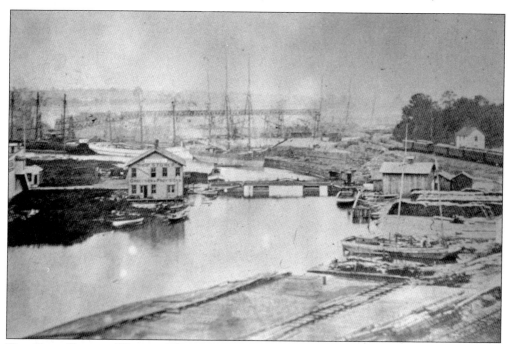

THE SAME VIEW IN WINTER. There is no ice in the water as yet, possibly indicating that the cold season is just coming on. (Courtesy of Ashtabula Marine Museum.)

SHIP CHANDLERY AND GROCERY STORE. This store, owned by Kate and Paul Cheney, was the site of the first masses celebrated at the Harbor in the summers of 1878–1879. The congregation which first came together here would form the Mother of Sorrows Parish in 1890. (Courtesy of Ashtabula County District Library.)

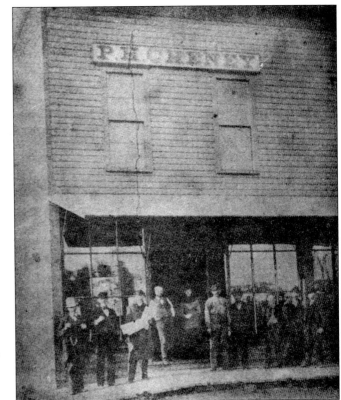

THE "STRAWBERRY BOX" IN AN 1894 PHOTOGRAPH. This device was the first coal-unloading machine on the Great Lakes. (Courtesy of Ashtabula Marine Museum.)

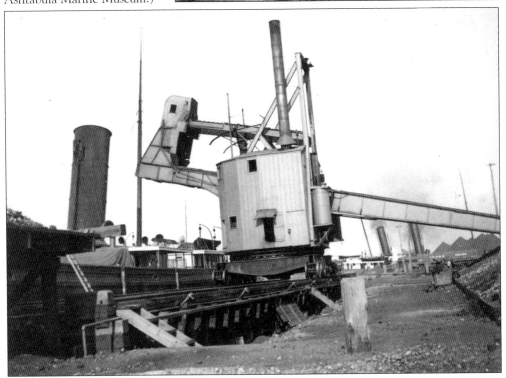

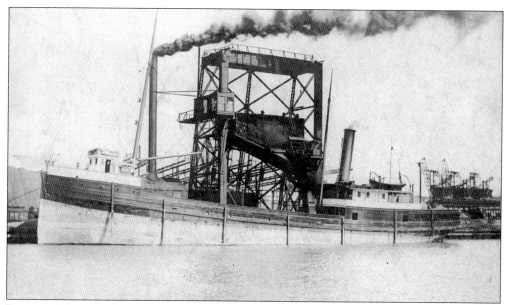

PICKANS MATHER CORPORATION COAL MACHINE IN 1884. A hopper car is tipped over to dump its contents into the hold of the boat, the *Schoolcraft*, out of Trenton, Michigan. She would be destroyed by fire in Kingston, Ontario, in 1920. (Courtesy of Ashtabula Marine Museum.)

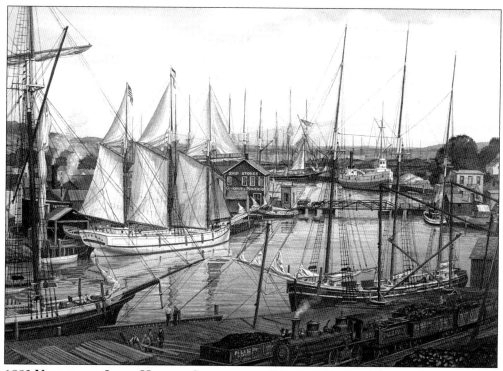

1883 VIEW OF THE INNER HARBOR, SHOWING THE PONTOON BRIDGE. This was the first of three bridges which have spanned the Ashtabula River here. (Courtesy of Ashtabula Marine Museum.)

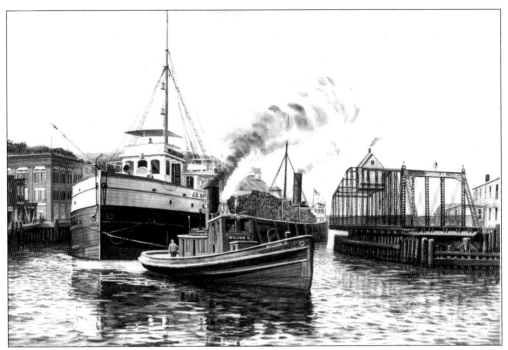

SWING BRIDGE OVER THE ASHTABULA RIVER AT BRIDGE STREET. Apart from drawbridges, there are three types of movable bridges: bascule, vertical lift, and swing. This example of the latter was built in 1889 to replace the Pontoon Bridge. (Courtesy of Ashtabula Marine Museum.)

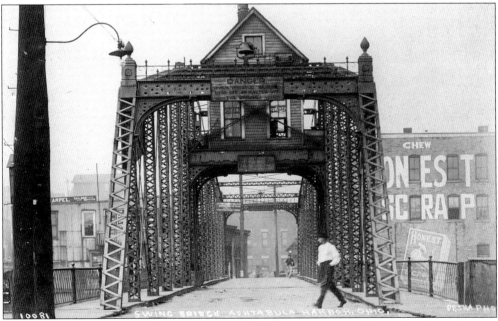

LOOKING THROUGH THE SWING BRIDGE. In 1925 this bridge would be replaced by a bascule bridge (shown on next page), usually referred to as the Lift Bridge, which still operates today. (Petros Collection.)

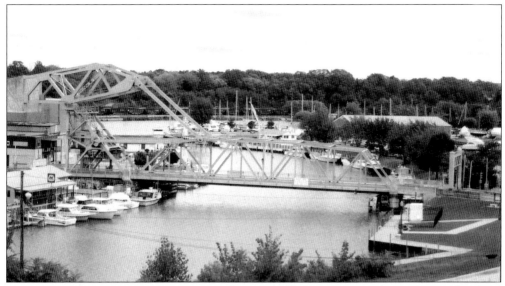

ASHTABULA'S FAMOUS LIFT BRIDGE. The Wendell P. Brown Company from Cleveland built the bridge in 1925 for approximately $179,000 following a general design by Thomas E. Brown, the New York City engineer who designed the Eiffel Tower elevator. From May through September the bridge is lifted by twin 75-horsepower electric motors twice each hour. Pleasure boats, which are berthed in marinas further south in the river, are the primary traffic today. (Borsvold Collection.)

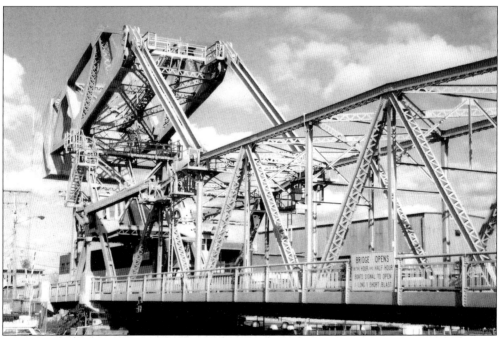

THE STURDY COUNTERWEIGHT ASSEMBLY OF THE LIFT BRIDGE. The weight is a concrete block of impressive size that does not encourage loitering in its shadow! A bridge tender is on duty around the clock except for January, February, and March. The bridge, one of only two of its type which remain in Ohio, was fully restored in 1986. (Borsvold Collection.)

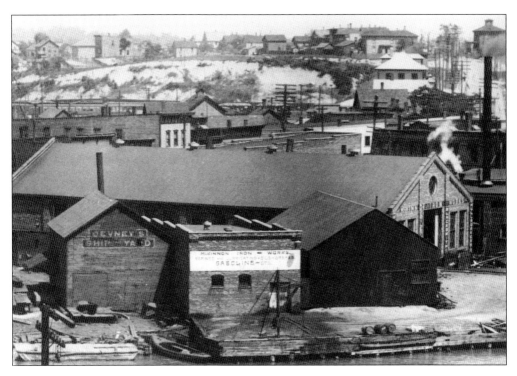

Two Views from the Ashtabula River About a Century Ago. The top photo includes the shipyards and the McKinnon Iron Works. In the bottom photo are freight cars from the "Big Four" Railroad (the Cleveland, Cincinnati, Chicago, and St. Louis), later absorbed by the New York Central. (Both courtesy of Ashtabula Marine Museum.)

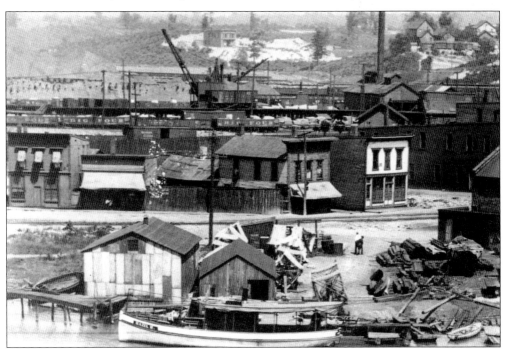

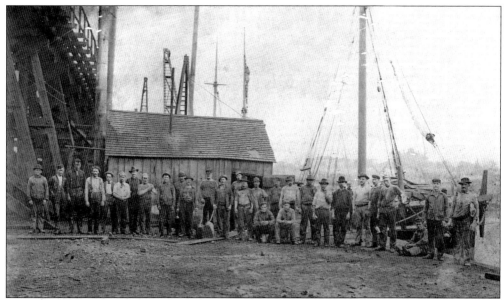

THE P, Y & A DOCK CREW RESTS AFTER A HARD DAY'S WORK IN 1890. Over the next few years, a series of increasingly sophisticated machines would take over much of their labor. (Courtesy of Ashtabula Marine Museum.)

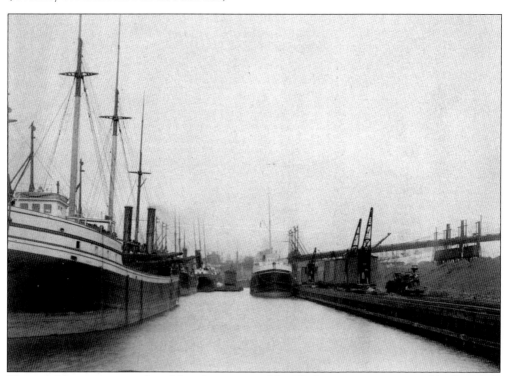

VESSELS UNLOADING IN SLIP NO. 5, c. 1890. The Harbor was growing quickly. By 1916, with 1,837 steam and 162 sailing ships active on the Great Lakes, Ashtabula would be the third-busiest harbor in the system, behind only Duluth-Superior and Buffalo and just ahead of Cleveland. (Courtesy of Ashtabula Marine Museum.)

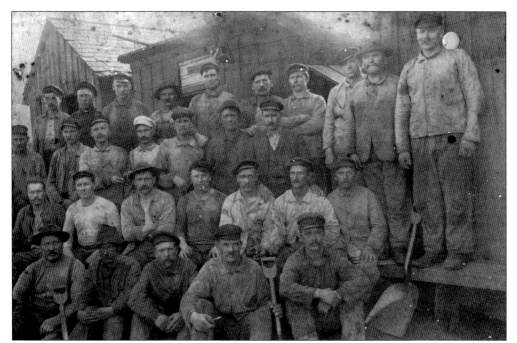

A NEWLY-DISCOVERED PHOTOGRAPH. At the Marine Museum in September 2002, an unexpected treasure was found, hidden many years ago in between another framed photo and its backing. This undated but clearly very old photo shows Finnish-American Ashtabula workers. (Courtesy of Ashtabula Marine Museum.)

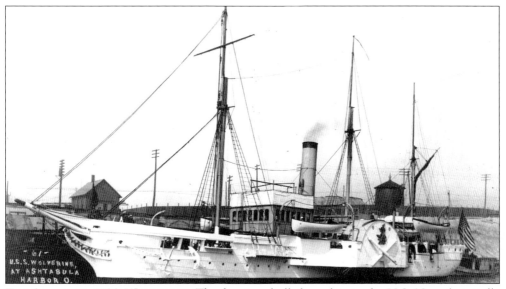

THE SCHOONER USS WOLVERINE. The first iron-hulled warship in the U.S. Navy (originally launched as the *Michigan*) lies at anchor in Ashtabula Harbor. One hundred and sixty-seven feet long, she was built in Pittsburgh and Erie, powered by both sails and side-paddlers, and had a displacement of 450 tons. The prow of the ship, rescued from decay and neglect in an Erie city park, was restored and is on permanent display at the Erie Maritime Museum. (Courtesy of Ashtabula Marine Museum.)

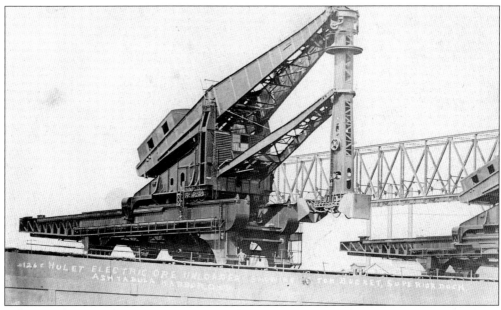

HULETT ORE UNLOADERS IN ASHTABULA HARBOR. At the turn of the century George Hulett, a native of Conneaut, invented an unloader which greatly accelerated the transferring of ore from ships to railroad cars. The first of these was built at Conneaut Harbor in 1899. Those in Ashtabula were "third-generation" units dating from 1908, each with an improved capacity of 15 tons per bite. This postcard was shot on March 4, 1910 by John J. Lee Photo Supplies and Finishing, located at the Harbor. (*Cleveland Press*, Special Collections, Cleveland State University Library.)

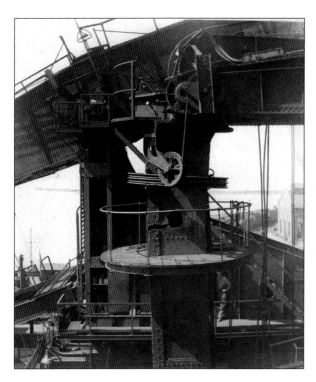

HULETT UNLOADER AT WORK ON ASHTABULA'S UNION DOCK. The eight Huletts in Ashtabula once set an unloading record, removing 70,000 tons of ore from seven boats in 22 hours' working time. In this photo, a large structural break is apparently not cause for concern among the crew! (Courtesy of Ashtabula Marine Museum.)

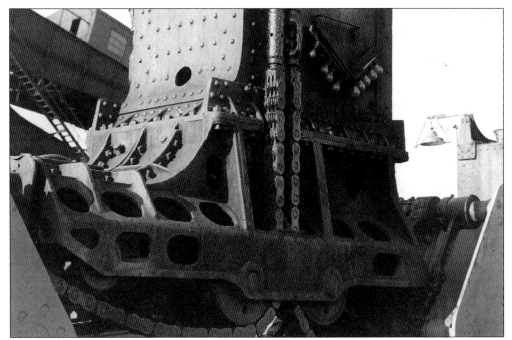

DETAIL OF A HULETT BUCKET. One "bite" of the Hulett Unloader could pull as much as 17 tons of ore from the hold of a ship. The controls were located directly above the jaws of the machine. One can only admire the skill of the operator, putting up with choking dust and a good deal of noise, yet mastering the complex articulated motion of this unique mechanism. (Herbert Satterlee photo, courtesy of Ashtabula County District Library.)

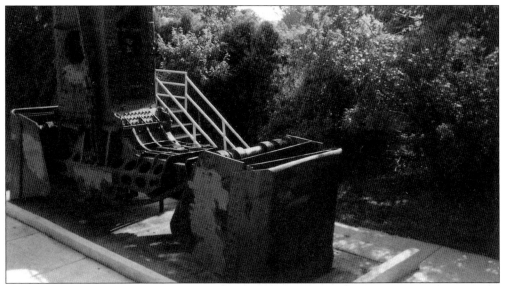

THE GRAB BUCKET AND OPERATOR'S BOOTH FROM ONE OF ASHTABULA'S HULETT UNLOADERS, PRESERVED IN POINT PARK. Visitors can climb a short staircase, step in, and imagine that they are working the controls at the end of the Hulett's 58-foot-long digging leg. Today two Huletts still stand in Chicago, and thanks to the efforts of preservationists two of Cleveland's four machines were saved, though disassembled. (Borsvold Collection.)

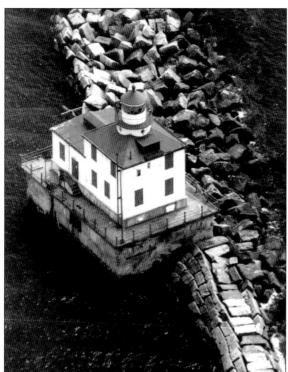

A New Lighthouse. Built in 1905, the third Ashtabula Lighthouse was moved further out into the water when the breakwater was extended in 1916. (Dee Riley photograph, courtesy of Ashtabula Marine Museum.)

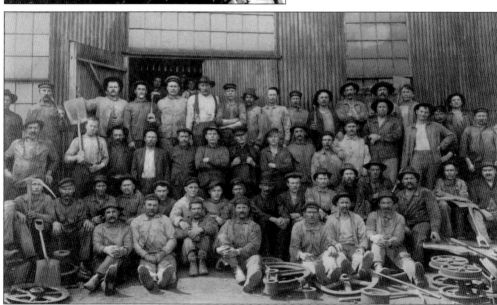

The Fast Plant Shovelers of the M. A. Hanna Dock, August 28, 1906. Long before the sophisticated Huletts, there were strong men with shovels and wheelbarrows who daily undertook the grueling and tedious task of transferring coal and ore between ships, docks, and trains. Shovelers were still needed for years to fill the tubs of early mechanized systems such as Alexander Brown's "Electric Fast Plant," and to pick up spillage from more advanced machines. These tough guys were no doubt looking forward to an evening of liquid refreshment on Bridge Street. (Courtesy of Ashtabula Marine Museum.)

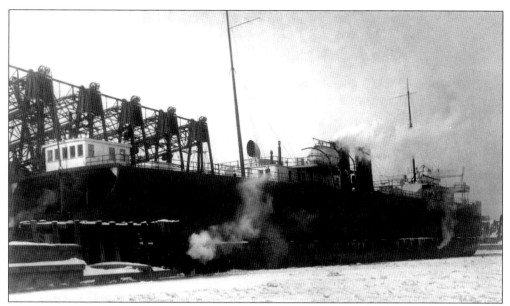

THE PENNSYLVANIA RAILROAD CARFERRY *ASHTABULA*. Newly built by Lake Boiler Works, the boat is shown laying at her slip in 1906 or shortly thereafter. Below-decks were four tracks with a capacity of 30 freight cars. Making the 51-mile crossing in three hours and forty-five minutes, she was the last carferry to operate on Lake Erie. (Courtesy of Ashtabula Marine Museum.)

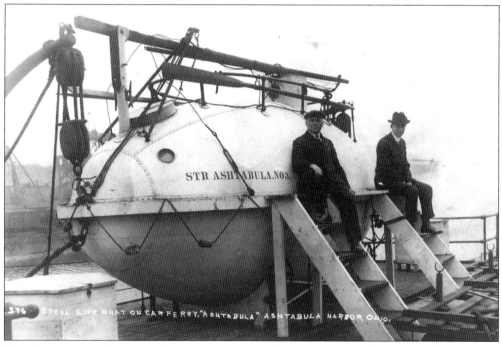

THE DECK OF THE CARFERRY *ASHTABULA* WITH A BRUDE LIFEBOAT. The men in the photo are representatives of Phoenix Foundry and Machine, Ashtabula, which built the lifeboats. Lifeboats had the defect of taking more time to prepare than most sinkings allowed, although in the collision of the *Ashtabula* none were needed (see p. 62). (Courtesy of Ashtabula Marine Museum.)

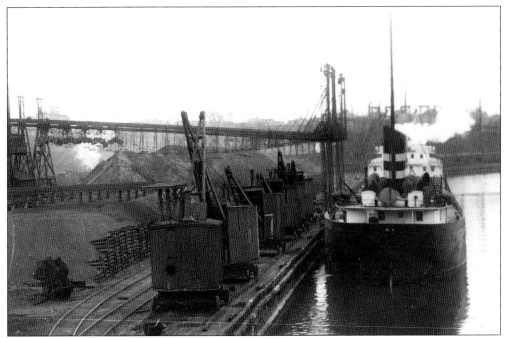

"Whirlies" on the Pennsylvania Railroad Dock. These interesting-looking steam-powered revolving McMyler cranes had grab buckets and were relatively efficient at removing ore from the holds of ships. Smaller versions of these machines were installed on early self-unloading boats. (Petros Collection.)

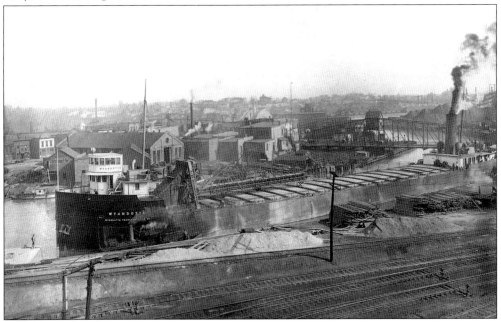

The Wyandotte Docks on the West Side of the River. The distant future of the Great Lakes harbors was first glimpsed in 1908 when the Michigan Alkali Company built the *Wyandotte*, the first self-unloading vessel in the Lakes. Since the 1970s self-unloaders have been the rule, requiring far fewer men or machines on the docks. (Courtesy of Ashtabula Marine Museum.)

26

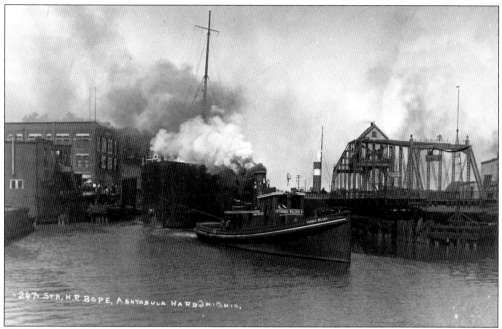

THE TUG *THOMAS WILSON* STEAMS FORWARD PAST THE SWING BRIDGE WITH STEAMER *H.P. BOPE* IN TOW, 1908. Unlike many of today's vessels which have thrusters, the ships of this era required towing near the docks and to make the bend in the River, past which were the shipyards. (Courtesy of Ashtabula Marine Museum.)

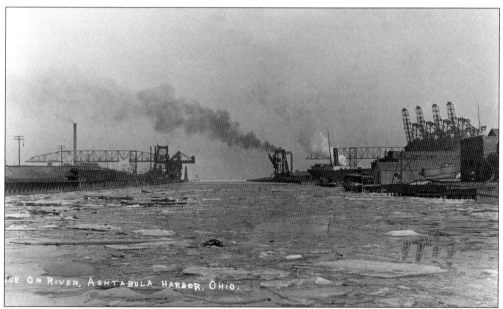

ICE CLOGS THE HARBOR IN 1912. Four Pickans Mather clamshell machines are on the right, along with two Hoover Mason traveling bridge cranes and two McMyler coal dumping machines at center. The Hoover Mason cranes utilized a large automatic grab bucket which first bit into the ore, then scraped along horizontally and closed on its load. (Courtesy of Ashtabula Marine Museum.)

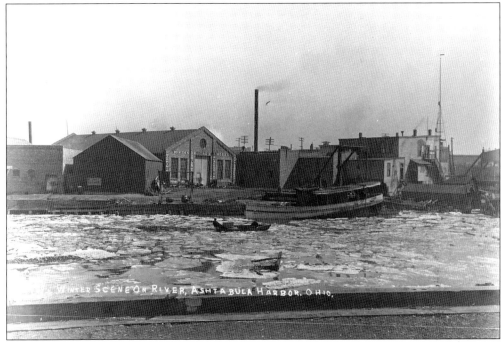

WINTER ON THE ASHTABULA RIVER IN 1912, IN FRONT OF THE MCKINNON IRON WORKS. (Courtesy of Ashtabula Marine Museum.)

HISTORIC STREET GRATE. Although the old McKinnon Iron Works closed in the 1950s, durable and functional reminders of the foundry are still seen today throughout the streets of the city. (Borsvold Collection.)

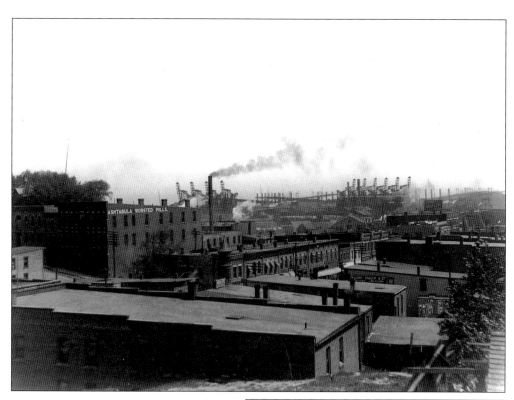

ROOFTOP VIEW OF BRIDGE STREET. This undated photo offers an unconventional and interesting northward view toward the Harbor. (Courtesy of Ashtabula Marine Museum.)

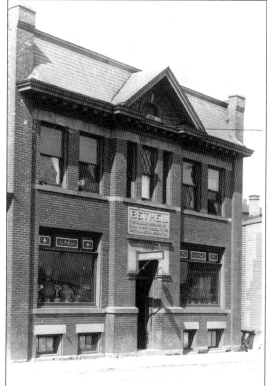

THE SEAMEN'S BETHEL ON MORTON DRIVE (NOW GOODWILL DRIVE). Built in 1906, it operated variously as a church-sponsored boarding and, during rougher days, as a "house of ill repute." This building has since been torn down. (Courtesy of Ashtabula Marine Museum.)

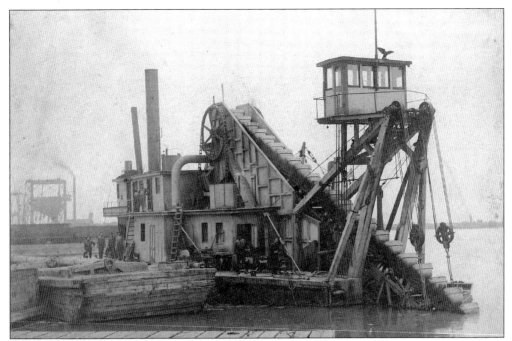

OLD DREDGING MACHINE IN THE HARBOR. Silt accumulation and the maintenance of an adequate harbor depth are problems which must be dealt with in any port. Today the Ashtabula River is seriously overdue for dredging, not only because of insufficiently deep draft clearances, but also to remove sediments contaminated with chemical waste from the Fields Brook industrial area upstream. Due in part to questions over where to relocate the sludge and how to finance the removal, plans for dredging in 2002 were delayed by at least two years. (Petros Collection.)

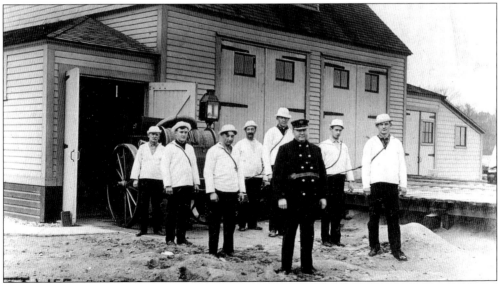

THE LIFE SAVERS ON THE LAKEFRONT. This undated photo shows the group responsible for firing the Lyle Cannon, which shot a Life Line far out into the Lake to aid vessels or swimmers in distress. (Courtesy of Harbor-Topky Memorial Library.)

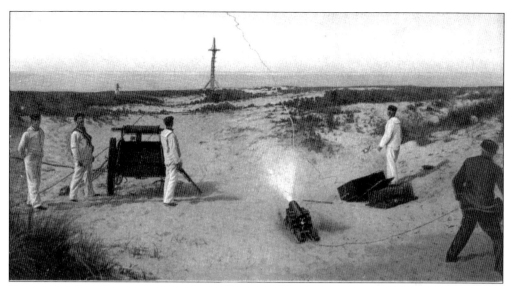

FIRING THE LIFE LINE WITH THE LYLE CANNON. The brass cannon, in perfect condition, is on display at the Ashtabula Marine Museum today. (Petros Collection.)

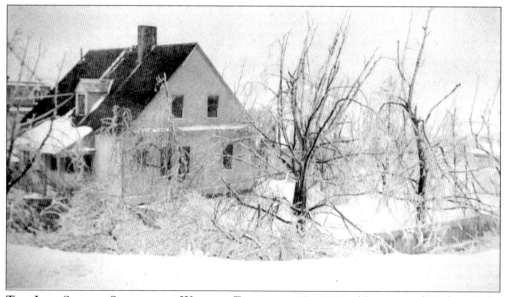

THE LIFE SAVING STATION IN WINTER, FEBRUARY 17, 1909. (Courtesy of Harbor-Topky Memorial Library.)

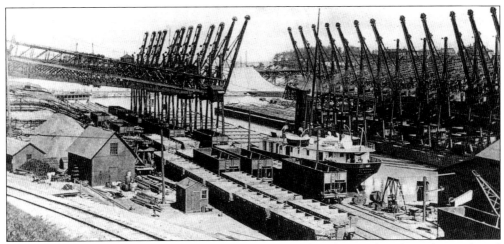

A 10,000-Ton Vessel is Unloaded at the Dock. This photo, taken from the south end of the Harbor about a century ago, shows Alexander Brown's "Tom Collins" cable rig, at the location of the present-day AYC slip. (Courtesy of Ashtabula Marine Museum.)

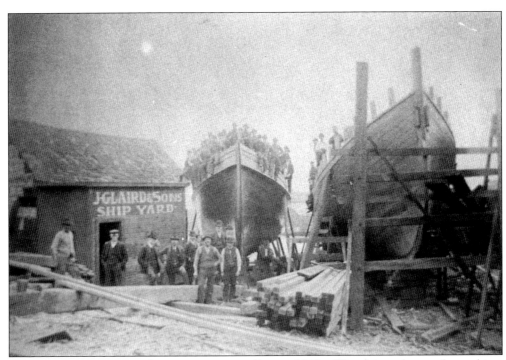

Workers at the Laird Shipyards in the Early 1900s. The shipyards were located just north of the Swing Bridge. The same company later operated lumberyards locally. (Courtesy of Ashtabula Marine Museum.)

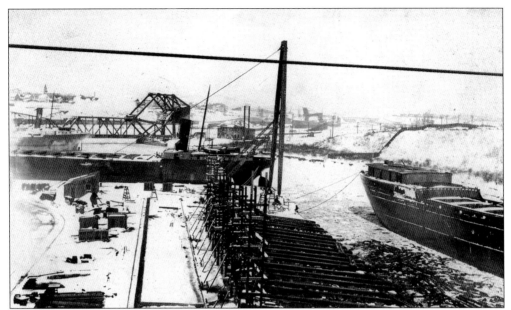

THE SHIPYARDS IN WINTER. A chilly view of the slip-way, down which newly-christened ships were launched with a great splash and festivity. (Courtesy of Ashtabula Marine Museum.)

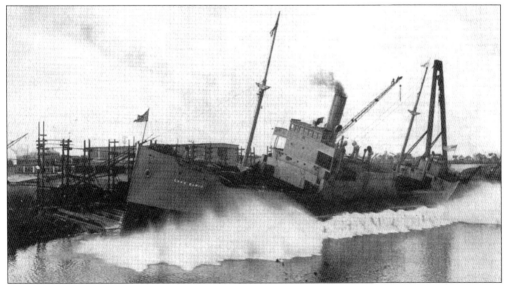

THE *LAKE ELRIO* IS LAUNCHED, 1919. One of many ships built along the Ashtabula River, she traveled far and wide. Later renamed *Paria*, she worked under allocation to the Colombian Steamship Company, and was sold to the International Packing Company in 1928. By the 1960s the demand for increased length in the new Lake boats became too great for them to negotiate the bend in the River. Ashtabula's shipbuilding days were over, and the shipyard property was sold. Marinas are located past the bend today. (Courtesy of Harbor-Topky Memorial Library.)

THE STEAMER COMET IN DRYDOCK AT THE G.L.E.W. (GREAT LAKES ENGINEERING WORKS) SHIP YARD IN THE 1920S. (Courtesy of Ashtabula Marine Museum.)

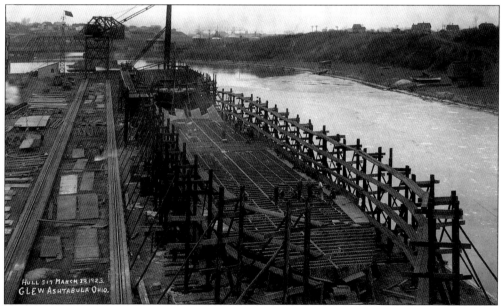

HULL 517 UNDER CONSTRUCTION, G.L.E.W., 1923. The New York Central Railroad bridge is in the background in this northward view. Shipbuilding and maintenance were a major part of the Ashtabula Harbor economy until 1965, when the increasing size of the new ore boats made it impossible to make the turn in the Ashtabula River south of the Lift Bridge. A great many retired ships were also cut up for scrap in the Harbor. (Petros Collection.)

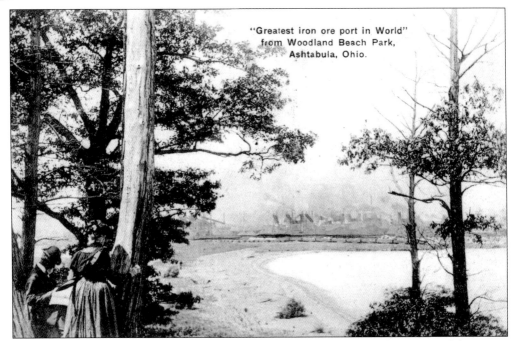

"Greatest iron ore port in World"
from Woodland Beach Park,
Ashtabula, Ohio.

INDUSTRIAL AREA SEEN FROM WOODLAND BEACH PARK. A hazy, distant image of the cranes and smoke of the docks is seen in this postcard view from the wooded setting of the park, located just to the west of Lake Shore Park. (Borsvold Collection.)

THE MERRY-GO-ROUND AT WOODLAND BEACH PARK. The park was a major regional attraction from the 1880s to the 1920s, drawing many visitors to its rides, dance pavilion, and beach. (Courtesy of Harbor-Topky Memorial Library.)

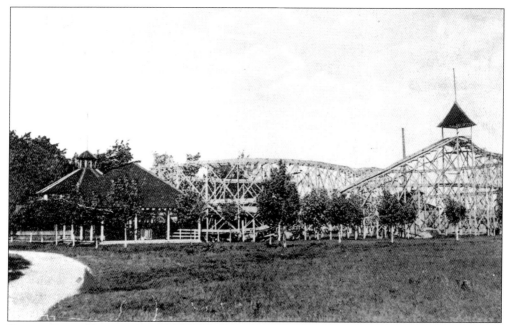

FIGURE-EIGHT ROLLERCOASTER AT WOODLAND BEACH PARK. After years of decline, the park would be torn down in 1929, and 26 years later the Pinney Dock would be built on this spot. (Courtesy of Harbor-Topky Memorial Library.)

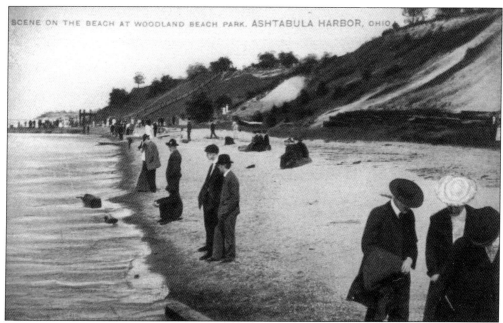

SCENE ON THE BEACH AT WOODLAND BEACH PARK. ASHTABULA HARBOR, OHIO

THE BATHING BEACH. This marvelous postcard image evokes an era when formal attire prevailed, even at the beach. (Courtesy of Harbor-Topky Memorial Library.)

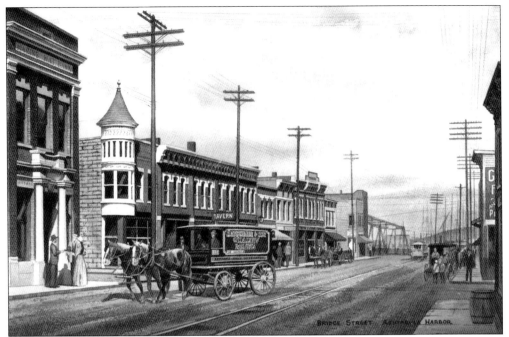

UNDATED VIEW OF BRIDGE STREET (5TH STREET). Its taverns were long a haven for sailors and dock workers, who unwound from a day's labor in rowdy fashion. Bridge Street gradually fell into decline as harbor traffic diminished after mid-century. In the 1970s, a renewal effort was begun here, with many old buildings and storefronts being restored to their original condition. A number of new businesses have opened here in recent years. (Courtesy of Ashtabula Marine Museum.)

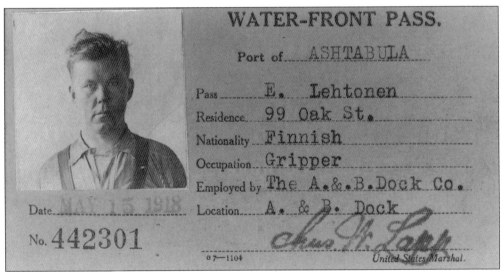

WORK PERMIT CARD FOR THE HARBOR, WORLD WAR I. To work his job at the Ashtabula and Buffalo Dock Company during wartime, Einar Lehtonen, a Finnish national, was required to show this card. It was not considered beyond possibility that enemy agents could strike at the Harbor area, and so everyone had to be cleared to enter the docks. The pass was "revocable at any time," and did not exempt the holder from a search of his person. (Courtesy of Charlotte Lehto.)

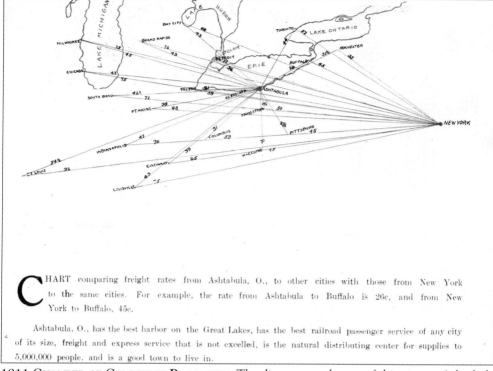

C HART comparing freight rates from Ashtabula, O., to other cities with those from New York to the same cities. For example, the rate from Ashtabula to Buffalo is 26c, and from New York to Buffalo, 45c.

Ashtabula, O., has the best harbor on the Great Lakes, has the best railroad passenger service of any city of its size, freight and express service that is not excelled, is the natural distributing center for supplies to 5,000,000 people, and is a good town to live in.

1911 CHAMBER OF COMMERCE BROCHURE. The distances and costs of shipping to Ashtabula and New York, respectively, are analyzed. This was perhaps the only direct challenge ever made by Ashtabula to the Big Apple! (Courtesy of Harbor-Topky Memorial Library.)

DISTINCTIVE ASHTABULA ORE BRIDGE. This photo appears to have been taken looking northeast from the Pennsylvania Railroad docks. All of these immense bridges are now gone. (Herbert Satterlee photo, courtesy of Ashtabula County District Library.)

"SELLING" THE CITY IN ITS INDUSTRIAL HEYDAY. An invitation printed in a 1928 Chamber of Commerce publication. (Courtesy of Harbor-Topky Memorial Library.)

14 Points of Industrial Advantage in Ashtabula

1. in the most important center of population in the United States with 68,000,000 people living within a radius of 500 miles

2. located in an admirable and convenient place—"in the greatest industrial region of America"

3. three trunk line railways—two main lines, east, west and one south, the world's largest railway systems

4. with splendid Great Lakes port and waterway facilities to ocean

5. within a night's ride of all principal cities east of Mississippi and north of Ohio rivers

6. midway between ore fields of north and coal fields of south,—meaning low freight rates

7. proximity to markets and steady, dependable labor supply

8. large tracts of low-priced land ideal for factory sites

9. unlimited supply of excellent water

10. steel and iron for all manufacturing and industrial purposes right at hand

11. raw materials are the closest distance —insuring lowest operating costs and where greatest net earnings are available

12. extensive railroad yards, warehouse and dock facilities,—assuring quick shipping

13. adequate and reliable electric power supply at low rates

14. a city free from debt—with a large cash surplus in its treasury

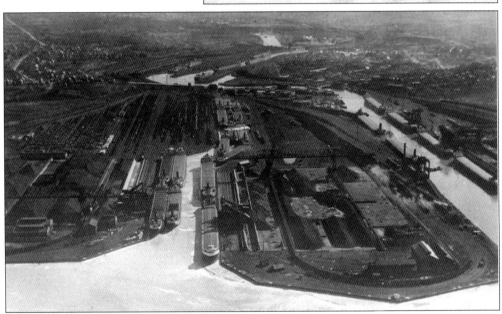

ASHTABULA HARBOR IN 1938. This view from the north shows a full complement of boats moored in the ice. Lake Erie does not freeze over completely except in colder-than-normal winters, but each summer and fall the fast pace of boat-and-railroad transshipping was based on the likelihood that it would do so. Every effort was made to move coal and ore in the highest volume possible, to balance the demand for these materials which continued through the winter. (*Cleveland Press*, Special Collections, Cleveland State University Library.)

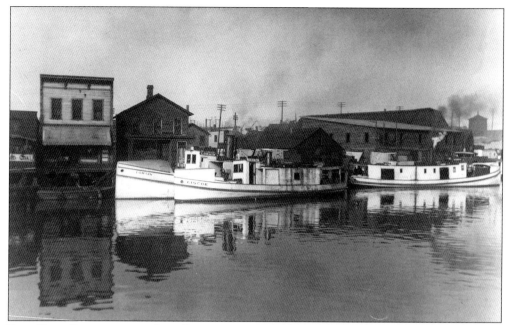

FISH TUGS SOUTH OF THE LIFT BRIDGE, c. 1915. These small, unpretentious fishing vessels were pragmatically built to withstand the rigors of Lake sailing and icy winters, and many of them have had service lives of over half a century. The two boats on the left used trap nets, the one at right gill nets. (Courtesy of Ashtabula Marine Museum.)

GILL NET FISHING BOAT. (Courtesy of Ashtabula Marine Museum.)

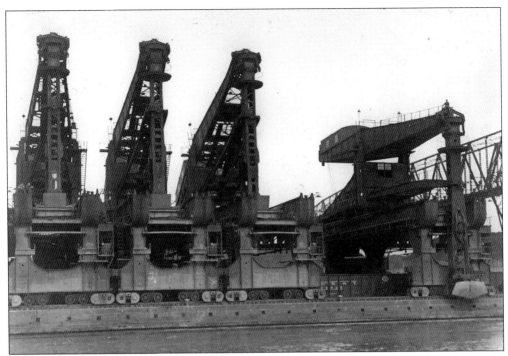

A 1940 VIEW OF THE HULETTS. These behemoths (commonly in groups of four) were in continuous service around the Great Lakes for decades, the last Ohio units being retired in Cleveland in 1992. The extremely complex motion of the Huletts required approximately five years for an operator to master fully. (Herbert Satterlee photo, courtesy of Ashtabula County District Library.)

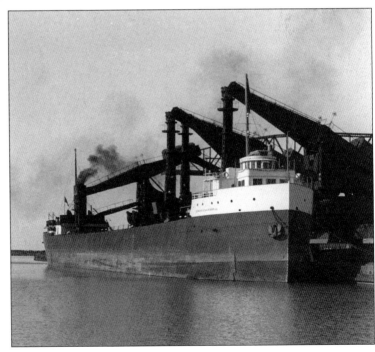

THE HULETTS UNLOADING ORE IN MINNESOTA SLIP. All of the Hulett Unloaders in Ashtabula Harbor were located on the New York Central's docks. (Herbert Satterlee photo, courtesy of Ashtabula County District Library.)

41

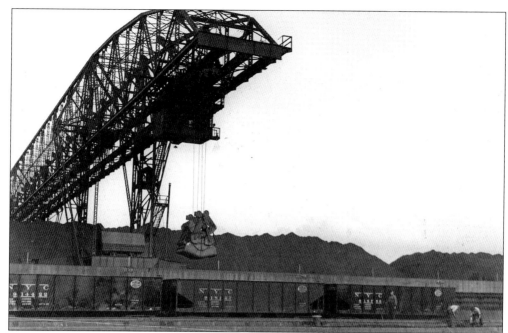

UNION DOCK ORE BRIDGE. This bridge, on the easternmost peninsula of the Harbor, utilized a Hoover and Mason hoist. (Herbert Satterlee photo, courtesy of Ashtabula County District Library.)

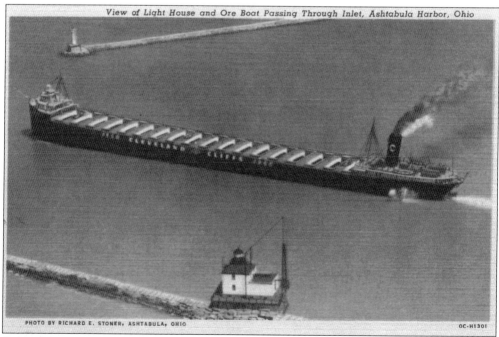

View of Light House and Ore Boat Passing Through Inlet, Ashtabula Harbor, Ohio

OC-H1301

CLEVELAND-CLIFFS BOAT POSTCARD. This great fleet, whose ships called so often at Ashtabula, was wiped out along with several other lines by the recession of 1980. Today Cleveland-Cliffs, concentrating on mining rather than shipping, is the leading supplier of high-quality iron ore products to the North American steel industry. (Borsvold Collection.)

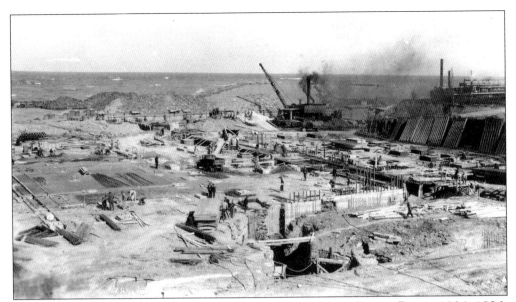

CONSTRUCTION OF THE CEI POWER PLANT NEAR LAKE SHORE PARK, 1924–1926. (Courtesy of Ashtabula Marine Museum.)

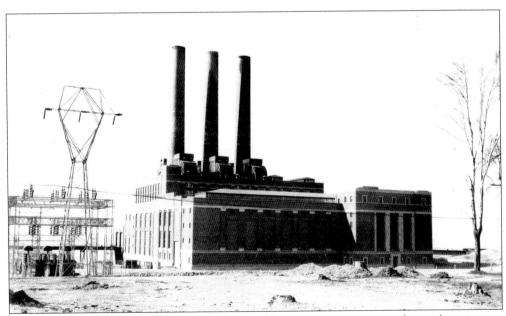

THE FINISHED PLANT. The utility owned several locomotives to move coal cars along its own railroad spur. (Courtesy of Ashtabula Marine Museum.)

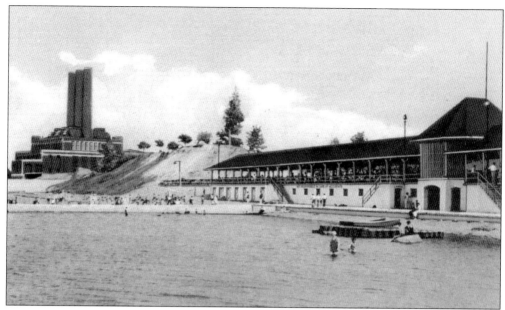

LAKE SHORE PARK BATHING BEACH AND THE CEI POWER PLANT. Lake Shore Park directly adjoined Woodland Beach Park. (Courtesy of Hubbard House.)

LAKE SHORE PARK IN A POSTCARD VIEW. Much of the park, located between the CEI plant and Pinney Docks, is still there today. (Borsvold Collection.)

CLEANING THE LIGHTHOUSE.
Maintenance of the lighthouse is the
major duty, along with lifesaving,
of the U.S. Coast Guard station in
Ashtabula. (Courtesy of Ashtabula
Marine Museum.)

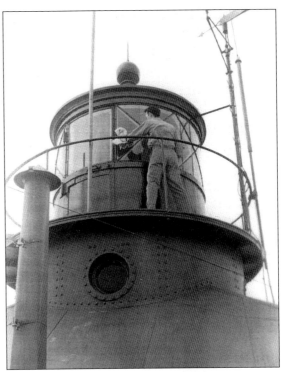

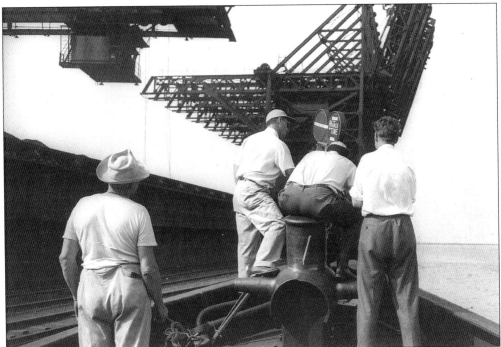

ASHTABULA MAKES THE NATIONAL NEWS. Amid the postwar industrial and economic boom,
a crew from "The March of Time" comes to P,Y & A Dock No. 10 on September 20, 1947, to
film a newsreel segment for the nation's movie theatres. Hoover and Mason ore unloaders tower
over the scene. (*Cleveland Press*, Special Collections, Cleveland State University Library.)

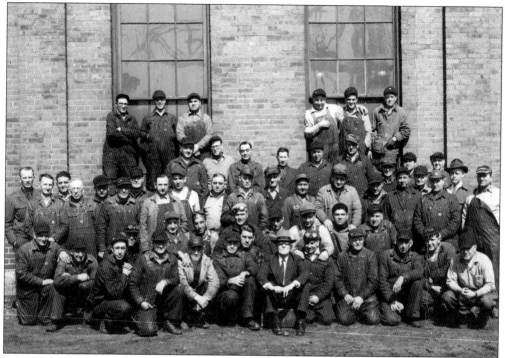

WORKERS AT UNION DOCK IN 1951. (Courtesy of Ashtabula Marine Museum.)

LOOKING EAST ALONG THE ORE BRIDGE AT UNION DOCK CO. For decades the ships and trains met here, but they would not have sustained such a high volume of transfer had their interdependence (and in some cases cross-ownership) not been promoted with favorable rates for shippers. (Courtesy of Ashtabula Marine Museum.)

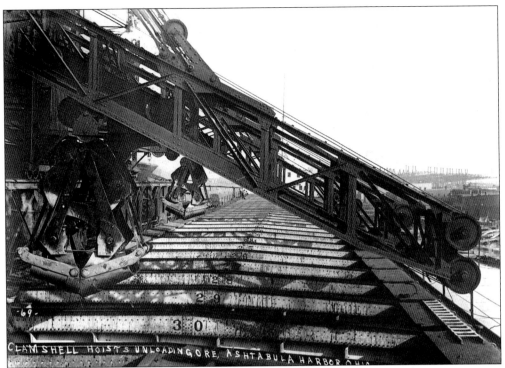

CLAMSHELL HOIST UNLOADING IN HENRY SLIP. After mid-century, the traffic in coal and ore steadily diminished, since the Appalachian coal seams are less productive than they once were and many steelworks in the region have closed. The harbor is a quieter place today. (Courtesy of Ashtabula Marine Museum.)

GREAT LAKES TUG OFFICE, LATE 1950S. The office was located on the west shore of the Harbor, alongside the Pennsylvania Railroad tracks. (Courtesy of Ashtabula Marine Museum.)

WALNUT BEACH IN THE LATE 1940S OR EARLY '50S. With seven acres of sand, the beach has long been a summer haven for sunbathers and swimmers. More recently, the adjacent wooded area has become popular with birders, who observe the shore's abundant avian wildlife from two specially-constructed high platforms. (Borsvold Collection.)

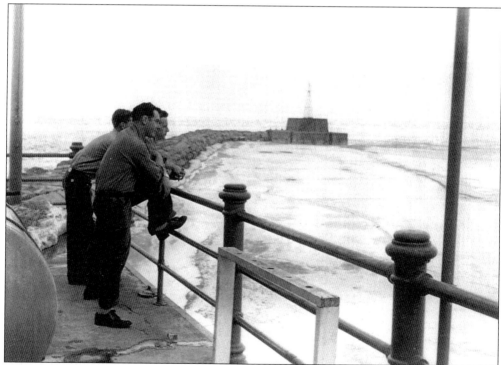

COAST GUARD MEN LINING THE RAIL AT THE LIGHTHOUSE. (Courtesy of Ashtabula Marine Museum.)

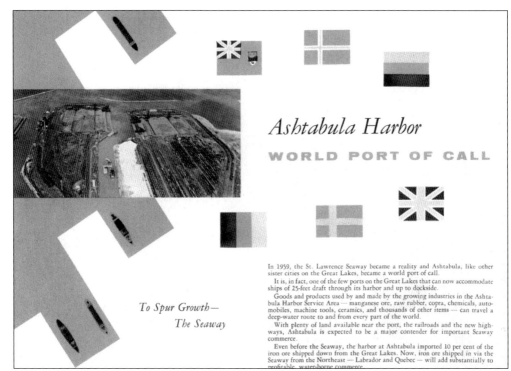

Ashtabula Harbor

WORLD PORT OF CALL

To Spur Growth —
The Seaway

In 1959, the St. Lawrence Seaway became a reality and Ashtabula, like other sister cities on the Great Lakes, became a world port of call.

It is, in fact, one of the few ports on the Great Lakes that can now accommodate ships of 25-feet draft through its harbor and up to dockside.

Goods and products used by and made by the growing industries in the Ashtabula Harbor Service Area — manganese ore, raw rubber, copra, chemicals, automobiles, machine tools, ceramics, and thousands of other items — can travel a deep-water route to and from every part of the world.

With plenty of land available near the port, the railroads and the new highways, Ashtabula is expected to be a major contender for important Seaway commerce.

Even before the Seaway, the harbor at Ashtabula imported 10 per cent of the iron ore shipped down from the Great Lakes. Now, iron ore shipped in via the Seaway from the Northeast — Labrador and Quebec — will add substantially to profitable water-borne commerce.

THE ST. LAWRENCE SEAWAY OPENS. Great optimism for new heights of commerce was awakened with the opening of the Seaway in 1959, since ore could now be brought from Labrador in addition to Duluth. But other factors were at work which would bring a slowdown, not an expansion, to Ashtabula's port operations in the near future. (Courtesy of Harbor-Topky Memorial Library.)

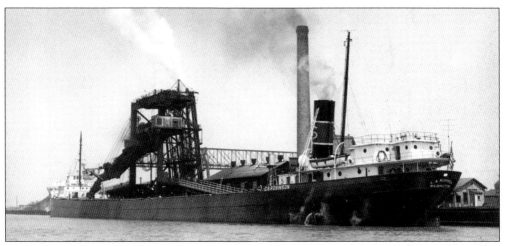

THE C.S. ROBINSON LOADING COAL IN ASHTABULA HARBOR, MAY 20, 1959. The golden age of the lake boat business would not last much longer. Fewer men were needed on the docks because of the increasing number of self-unloading ships and the decline of the Huletts and other dock-based unloaders. In addition, the newer boats' greater size and capacity meant that fewer total trips and a smaller number of dock personnel would be needed. (*Cleveland Press*, Special Collections, Cleveland State University Library.)

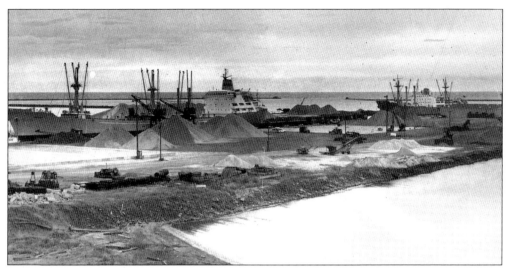

PINNEY DOCKS ON AUGUST 15, 1963. The 2,000-foot docks were built by Nelson J. Pinney in 1955–1957 on the former site of Woodland Beach Park, the amusement park whose rides and dance hall had been regional attractions for decades until its decline and, in 1929, its closure. A $5 million appropriation from Congress allowed for the dredging of a 25-foot-deep channel, ample for the draft of the largest ships. Pinney's aim was to attract the new ships bringing ore from Labrador in Canada, via the Seaway. (*Cleveland Press*, Special Collections, Cleveland State University Library.)

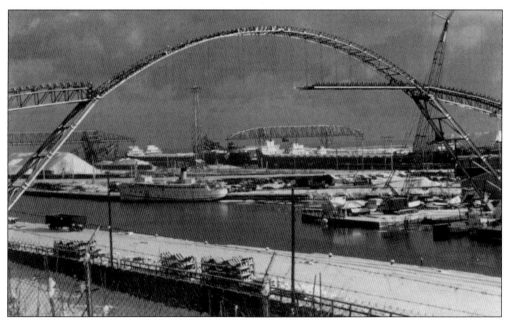

CONSTRUCTION OF ASHTABULA HARBOR'S CONVEYOR BELT, 1967–1968. Today this is one of the area's most visible landmarks. Vast amounts of Appalachian coal are unloaded from railroad hopper cars and brought across by the conveyor to the west side of the River, between the Lighthouse and Point Park, and kept in huge stockpiles to await transfer to ships. The coal piles are regularly doused by sprays of water from nozzles atop high poles, to keep airborne coal dust to a minimum. (Courtesy of Ashtabula Marine Museum.)

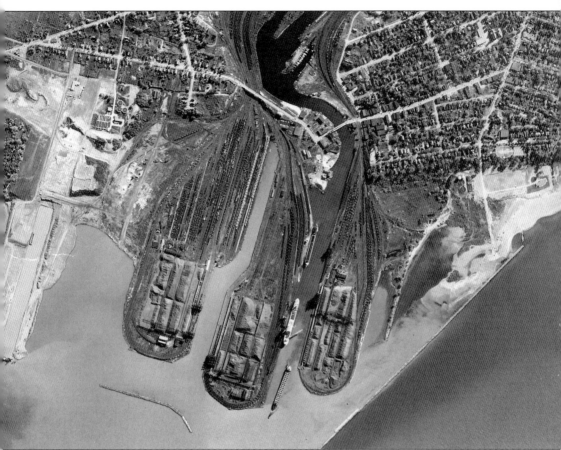

THE PORT OF ASHTABULA IN 1957. On the coastal area at far left is Lake Shore Park, and the first area which projects into Lake Erie is Pinney Dock (still under construction), formerly the site of Woodland Beach Park. The next two protrusions are the New York Central's docks (split by a channel called Minnesota Slip), and the Pennsylvania Railroad's dockyard is the right-hand peninsula. To the right of the PRR is the breakwater with the Lighthouse, and Walnut Beach is at far right. (*Cleveland Press*, Special Collections, Cleveland State University Library.)

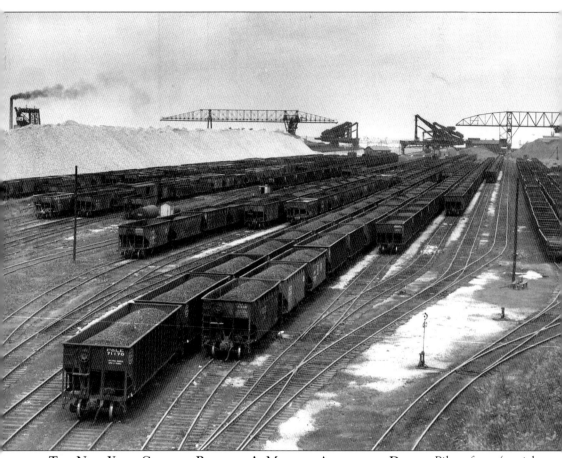

THE NEW YORK CENTRAL RAILROAD'S MASSIVE ASHTABULA DOCKS. Piles of ore (at right under bridge) and limestone (left) are seen in this September 1961 photo of the west side of Minnesota Slip. The quartet of Hulett unloaders on the left was operated by Pickans Mather, those at right by Jones & Laughlin Steel (until 1978). The docks outlasted the railroad and its successor, the Penn Central, and survived into the Conrail era. One of the J&L Huletts broke down in 1972, and when another failed in 1978, 80 dockworkers were laid off. Conrail turned operations over to Pinney Dock in 1980, and all of the Ashtabula Huletts were soon scrapped. Norfolk Southern now controls access to the Harbor, with CSX exercising traffic rights over NS rails. (*Cleveland Press*, Special Collections, Cleveland State University Library.)

Two

ASHTABULA'S RAILROADS

Ashtabula at its industrial peak was a railroad town par excellence. It had everything a railfan could want: three roads in competition, a vast variety of motive power and equipment, fascinating dock operations, fast passenger trains, two roundhouses, yards, and colorful characters. The New York Central and the Pennsylvania went head-to-head in coal and iron ore operations at the Harbor and general freight hauling. The Nickel Plate also ran east and west through town and had a passenger station, but its roundhouse and yard were in Conneaut.

A great many Ashtabula citizens worked on one or another of the railroads, and fierce loyalties and partisanship prevailed. Steam locomotives, with their loud whistles and plumes of smoke, were ousted by less-spectacular diesels by the mid-1950s. The first-generation diesels, attractive streamlined cab units or Alco RS-3s with sloped shoulders, gradually gave way in the 1960s and 70s to increasingly boxy road-switchers at the same time as the formerly eye-catching paint schemes grew progressively duller. A rash of railroad mergers in the 1960s was precipitated by looming bankruptcies. In the early 1970s much of Ashtabula's distinctive and varied railroad scene disappeared under a gloomy, dirty umbrella of Penn Central black. Locomotive maintenance, employee morale and customer service hit bottom.

The solution was Conrail. Created by the U.S. government in 1976 to take over the bankrupt PC's operations, which were vital to the Northeast, "Big Blue" quickly streamlined operations (unfortunately for many, by severely cutting the size of its workforce). Conrail had become thoroughly profitable by the end of the century when, in a hostile takeover, its assets were divided between Norfolk Southern and CSX.

The photos which follow pick up the story of Ashtabula's railroads in the 1870s, when the first rails to the Harbor opened limitless avenues of commerce. Interurbans and city trolleys, which lamentably vanished from the scene before World War II, are represented as well.

53

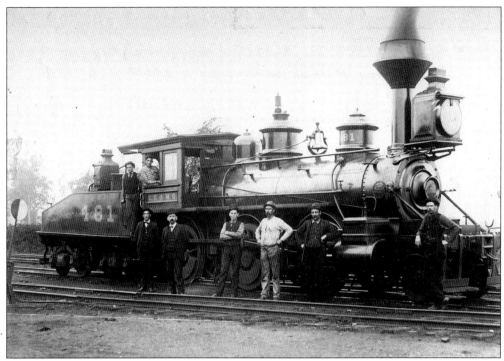

LAKE SHORE AND MICHIGAN SOUTHERN ENGINE AND CREW IN THE ASHTABULA YARDS, 1890s. The LS & MS, with its coveted flat lakeshore route, would be absorbed by the New York Central in 1914 over the objections of the Justice Department, which maintained that the NYC's control of this and several other lines amounted to a violation of antitrust laws. (Courtesy of Ashtabula County District Library.)

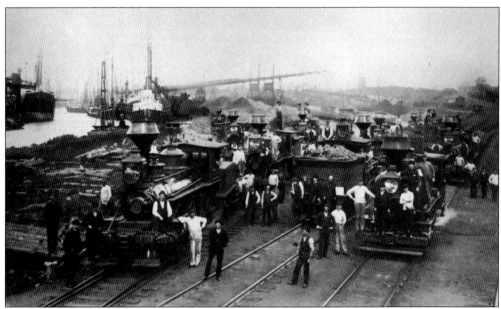

A NEW FLEET OF STEAM LOCOMOTIVES. This photo was clearly taken to celebrate the delivery of new motive power. (Courtesy of Ashtabula Marine Museum.)

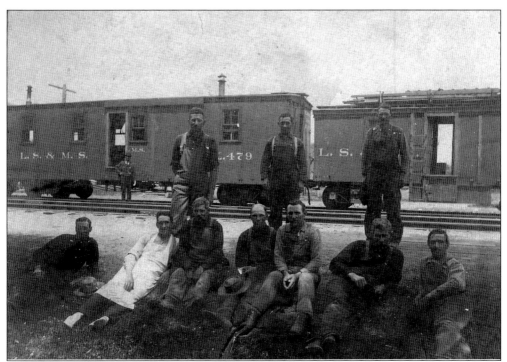

L.S. & M.S. Work Crew with Bunk Cars. (Petros Collection.)

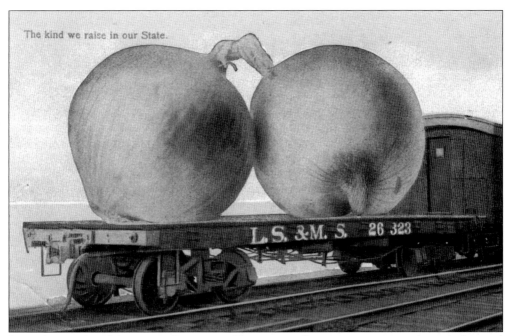

Lake Shore and Michigan Southern Postcard. Giant onions were only one of several types of fruits and vegetables shown on flatcars in a near-identical series of promotional postcards. (Borsvold Collection.)

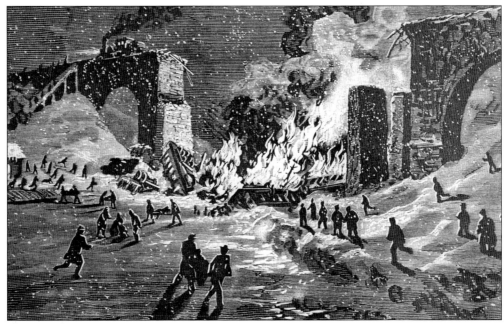

ASHTABULA RAILWAY DISASTER. At 7:29 p.m. on the snowy night of December 29, 1876, a deadly railway tragedy occurred. As a crowded passenger train (the LS & MS "Pacific Express") strained to push through deep snow atop a 165-foot-long bridge over the Ashtabula River, the braces gave way, sending 159 people plunging seventy-six feet toward the river—92 to their deaths, either from the fall or the catastrophic and unchecked fire that followed. The area into which the train fell was overgrown, covered in snow and inaccessible to vehicles, and the overmatched fire chief never gave the order for a bucket brigade. (Special Collections, Cleveland State University Library.)

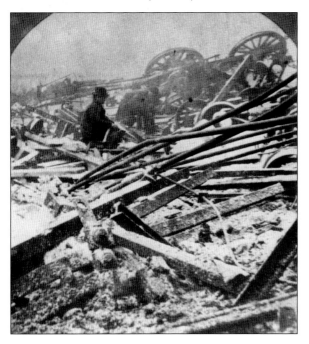

THE DISASTER IN THE STARK LIGHT OF THE MORNING AFTER. Streets were buried in unplowed snow, horses were stabled, and in the only access to this spot was a long staircase. By the time would-be rescuers had struggled single-file through snowdrifts and arrived on the scene 20 minutes after the crash, there was little that they could do but gaze at the flaming wreckage, a scene of carnage that made witnesses faint with horror. (Special Collections, Cleveland State University Library.)

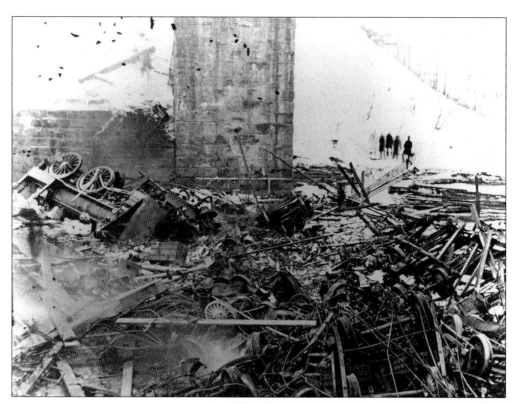

WRECKAGE OF THE LOCOMOTIVE. To make matters worse, a few onlookers began plundering and looting the scene almost immediately, while others futilely attempted rescue. By midnight the fire had burned out and all was quiet. The train's plunge attracted intense national attention for weeks afterward. Amazingly, the lead locomotive had escaped this fate by racing uphill as the tracks began to slope backward. (Courtesy of Hubbard House.)

A DISASTER OF LASTING INFAMY. "You've heered talk o' Johnstown?" Harvey considered. "Yes, I have. But I don't know why. It sticks in my head same as Ashtabula." "Both was big accidents-thet's why, Harve." –Rudyard Kipling, *Captains Courageous* (Special Collections, Cleveland State University Library.)

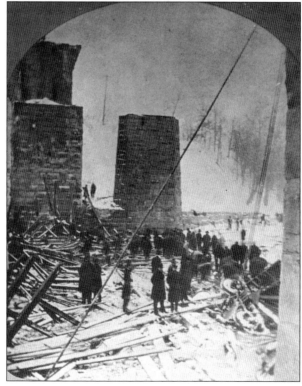

THE BRIDGE BEFORE THE ACCIDENT. Much of the blame for the design shortcomings of the poorly-constructed and ill-maintained iron Howe Truss bridge was laid at the feet of Cleveland millionaire railroad tycoon Amasa Stone, but one who took the disaster harder was chief engineer Charles Collins, who had regularly inspected the bridge and pronounced it safe. Collins, who wept uncontrollably at the sight of the smoking wreckage, went home and committed suicide with his pistol. (Special Collections, Cleveland State University Library.)

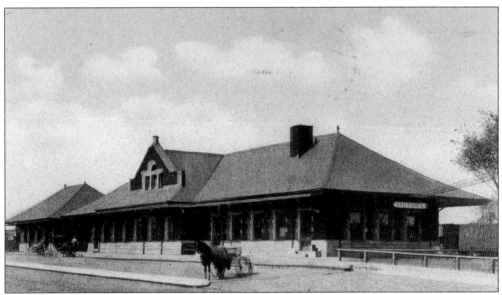

POSTCARD OF ASHTABULA DEPOT IN LAKE SHORE AND MICHIGAN SOUTHERN DAYS. This is the depot (still in excellent structural shape today) that the ill-fated train was approaching as the nearby bridge collapsed. (Courtesy of Ashtabula County District Library.)

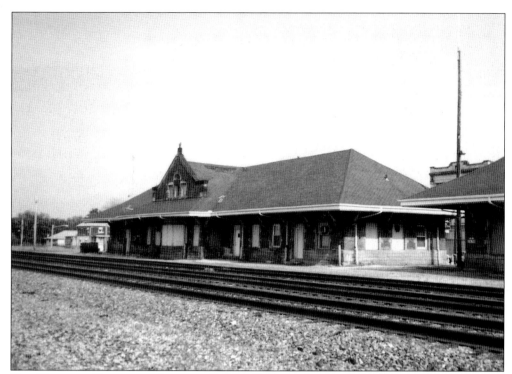

THE HISTORIC PASSENGER STATION IN 2002. These tracks, after the days of the LS & MS, became part of the New York Central's New York-to-Chicago raceway, the "Water Level Route," over which traveled the *20th Century Limited* and other fast trains. Passenger trains have not stopped in Ashtabula for decades, but the old station is kept in good condition as a storage area for CSX, which operates this portion of the Water Level Route today. (Borsvold Collection.)

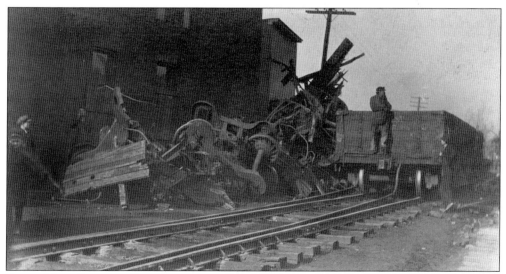

EARLY 20TH CENTURY POSTCARD OF AN L.S.& M.S. TRAIN WRECK BETWEEN CENTER AND PROSPECT. The building at left was the Richardson & Co. wholesale grocers. (Eleanor and Lawson Stevenson Collection.)

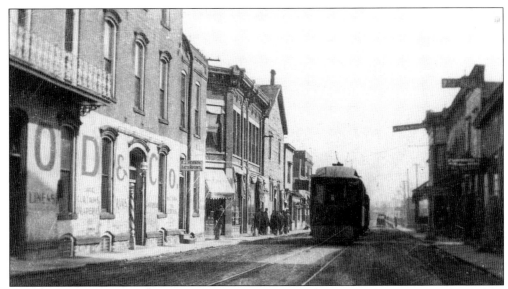

PENNSYLVANIA AND OHIO RAILWAY. This interurban line was founded in 1898 and opened for service on November 11, 1901, on a route which went northward from Jefferson to Ashtabula, and then east to Conneaut. In this photo a P&O streetcar is heading toward the Spring Street bridge. The line ceased operations on February 29, 1924. (Courtesy of Ashtabula County District Library.)

P&O INTERURBAN OFFICE ON E. 46TH STREET. (Petros Collection.)

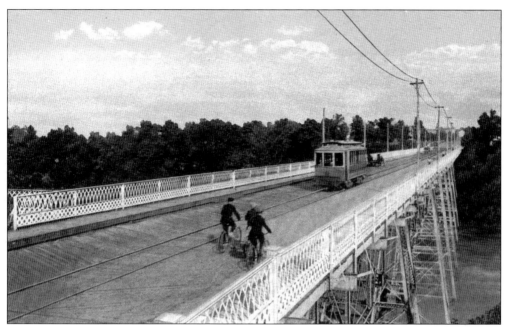

P&O Interurban Car on the High-Level Spring Street Bridge. Many local residents can recall the exaggerated manner in which this bridge (later converted for auto traffic) would shake under even moderate loads, before it was finally replaced in the 1990s. (Eleanor and Lawson Stevenson Collection.)

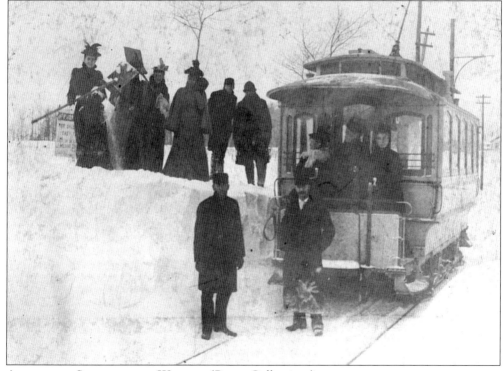

Ashtabula Streetcar in Winter. (Petros Collection.)

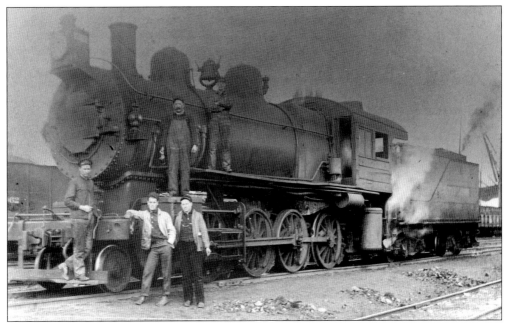

Pennsylvania Railroad Steam Locomotive and Crew in Ashtabula. The New York Central had a major advantage in the proximity of Ashtabula to its own high-speed main line, whereas the Pennsy had to content itself with its Ashtabula-Warren branch line, a high-volume coal and ore route that was less in demand for passenger business. (Petros Collection.)

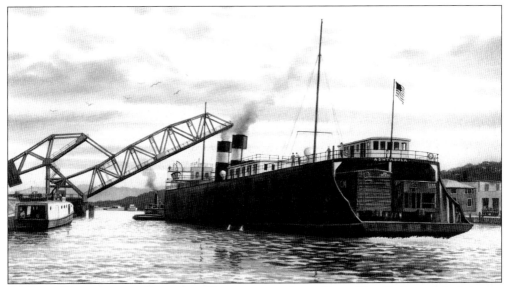

Sending Pennsylvania Railroad Cars Across Lake Erie. The Carferry *Ashtabula* was launched in 1906 and made thousands of round trips to Port Burwell, Ontario, where a connection was made with the Canadian National Railroad. Her service ended in Ashtabula when she settled to the bottom of the 27-foot deep inner Harbor (without submerging) at 8:02 p.m. on September 18, 1958, after colliding with the *Ben Moreell*. Though no one was killed in the accident, two deaths were caused by it: the captain of the *Ashtabula* later committed suicide, and an inspector took a fatal fall into a hole in the wreckage. (Courtesy of Ashtabula Marine Museum.)

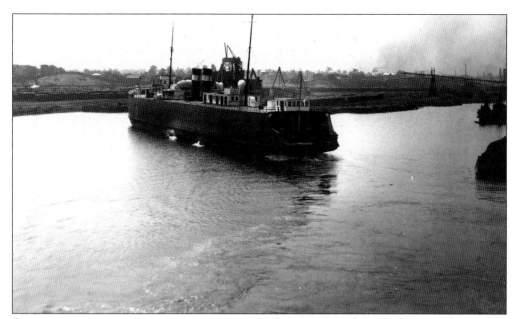

Carferry *Ashtabula* Leaving the Docks. Collision was not the only danger to these boats. Carferries, groaning with the tonnage of more than two dozen heavy-laden freight cars, were perilous vessels to operate. Nervous captains feared the sudden rolling or tipping of the cars, precipitating unbalanced loads and disasters such as occurred with two Conneaut carferries. (Courtesy of Ashtabula Marine Museum.)

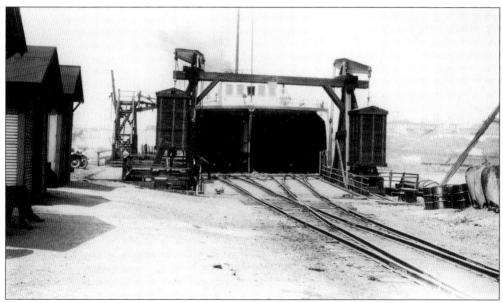

Entrance to the Carferry *Ashtabula*. This interesting view of the rail-to-rail connection shows a fascinating counterweight assembly meant to keep the boat at dock level when heavy freight cars were rolled in. (Courtesy of Ashtabula Marine Museum.)

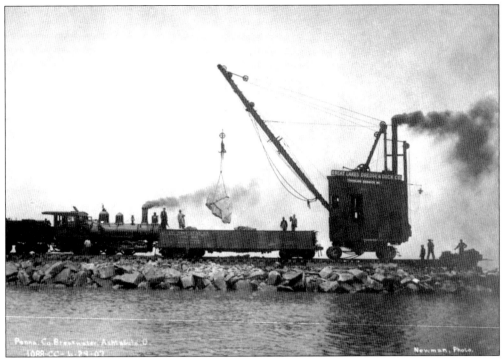

Steam-Powered Pennsylvania Railroad Crane, June 29, 1907. Track was laid at Slip No. 11 (also called Henry Slip) temporarily, to build the breakwater. This crane, similar to the McMyler "whirlies" used on the docks, may have been built by the same company. (Courtesy of Ashtabula Marine Museum.)

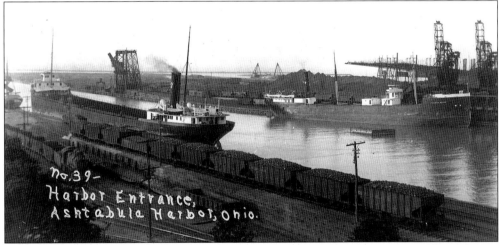

Competing Railroads in the Harbor, 1908. The *J.F. Durston* sits at the Pennsylvania Railroad coal dock on the left and, at right, the *Midland Queen* (which would be sunk in 1915 by the Germans off Fastnet, England) rests at the dock of the New York Central. McMyler coal-loading machines, seen on both docks in this photo, were slow and clunky, taking a full two minutes to lift and empty a hopper car. After the Penn Central merger in 1968, the railroad culture of the Harbor would never be the same, since the need for two separate docks disappeared literally overnight. (Courtesy of Ashtabula Marine Museum.)

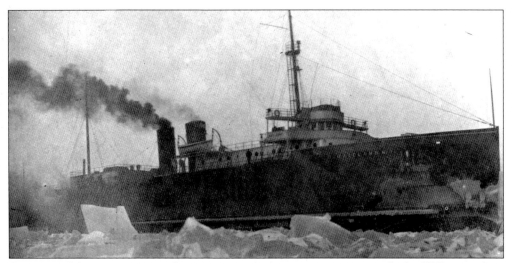

CARFERRY *MAITLAND* IN THE ICE, MID-1920S. Aiming to compete with the PRR in carferry service, the New York Central instituted a route from Ashtabula to Port Maitland, Ontario in 1916. Freight cars were brought to the NYC's Canadian affiliate, the Toronto, Hamilton and Buffalo Railway. There were two *Maitland* carferries, *No. 1* and *No. 2*, but no number is visible here. (Courtesy of Ashtabula Marine Museum.)

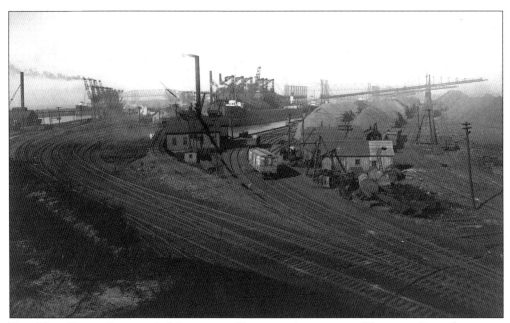

THE NEW YORK CENTRAL'S MINNESOTA DOCK IN ASHTABULA HARBOR. Curved turnouts are a testament to the railroad's need to branch out into several spurs in a very tight space. (Courtesy of Ashtabula Marine Museum.)

Facts About Ashtabula Railroads

THERE was a total of 9,028,269 tons or iron ore handled in 1926, forwarded in 136,029 cars; and 1,649,963 tons of coal received in 26,057 cars, by the Pennsylvania and the New York Central railroads.

In addition thousands of carloads of coal were ferried across the lake to Canada —as well as merchandise shipments.

A total of 44 passenger trains run in and out of Ashtabula on the 3 roads each twenty-four hours, and a total of 47 freight trains in and out of Ashtabula on the three roads during the same period.

The passenger and freight stations of the steam railroads are conveniently located near the business district.

Through excellent train service limited trains are operating between Ashtabula and New York, making the run in 13 hours; to Chicago in 9 hours.

The following table shows at a glance the approximate distance and time for freight movements from Ashtabula:

Cleveland, O.	54	1-day	Chicago, Ill.	411	4-day
Youngstown, O.	59	1-day	Ft. Wayne, Ind.	314	3-day
Akron, O.	100	3-day	Cincinnati, O.	351	4-day
Pittsburgh, Pa.	124	2-day	Albany, N. Y.	435	4-day
Buffalo, N. Y.	129	2-day	Philadelphia, Pa.	473	3-day
Wheeling, W. Va.	159	3-day	New York, N. Y.	564	4-day
Toledo, O.	167	2-day	St. Louis, Mo.	647	5-day
Detroit, Mich.	225	2-day	Chattanooga, Tenn.	690	7-day
Syracuse, N. Y.	277	3-day	New Orleans, La.	1272	7-day

All points on the Pacific coast 9 to 15 days.

Ample motive power is maintained by the railroads at Ashtabula to keep shipments moving swiftly.

ASHTABULA CHAMBER OF COMMERCE ADVERTISEMENT FROM 1928. (Photo courtesy of Harbor-Topky Memorial Library.)

RAILROAD LIFT BRIDGE, VIEWED FROM ABOVE THE PENNSYLVANIA RAILROAD TRACKS. The PRR and NYC tracks came up the west side of the river together, but at this point the Central had to cross over to approach its own docks. The bridge is operated by Norfolk Southern today. (Courtesy of Ashtabula Marine Museum.)

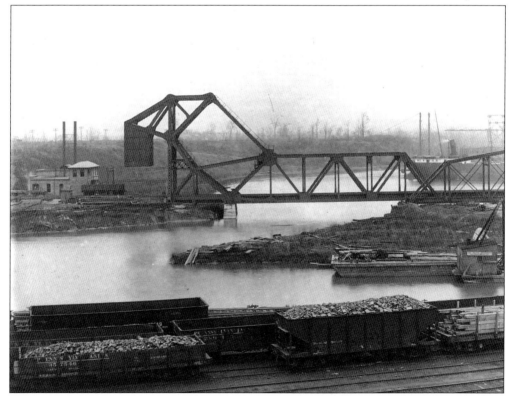

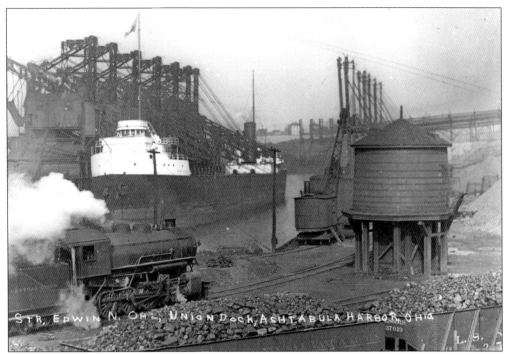

BUSTLING ACTIVITY AT THE ASHTABULA LAKEFRONT. The steamer *Edwin N. Ohl* is unloaded at Union Dock. A clamshell hoist is seen at left, and a Brown hoist is on the right. New York Central No. 5587, a 2-8-0 "Consolidation" of LS&MS G-46d class (renumbered in 1905), is pulling a string of hoppers into the frame. (Courtesy of Ashtabula Marine Museum.)

YARD THROAT APPROACHING PENNSYLVANIA RAILROAD DOCKS. This view, looking west, shows that part of the hillside has been cut away to allow more PRR tracks to be laid. The Pennsy was forced to operate in far less space than the New York Central across the Harbor. (Courtesy of Ashtabula Marine Museum.)

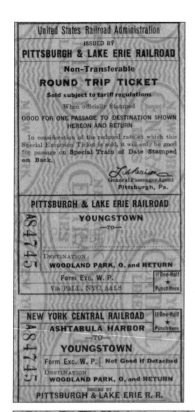

PITTSBURGH AND LAKE ERIE TICKET, 1919.

Beginning in 1884, it was very common for tourists from Pittsburgh to ride the train in and spend a day at Woodland Beach Park, a popular amusement park with a dance pavilion, rides, and bathing beach. (Courtesy of Harbor-Topky Memorial Library.)

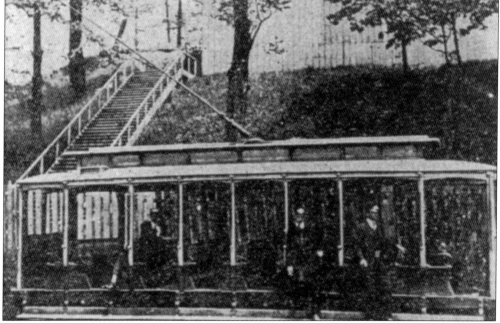

"THE SHORTEST LINE IN THE COUNTRY." Motorman John C. Farrow and Conductor Cliff Sleeper run an open-air special on the one-mile-long trolley line to Woodland Beach Park that connected the park to the east end of the Lift Bridge. The line was in service until just after World War I. (Courtesy of Harbor-Topky Memorial Library.)

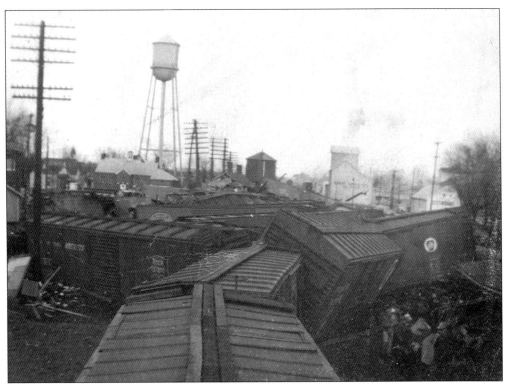

TRAIN WRECK IN 1939. The railroad's first task in a routine derailment is always to bring in the crane and clear the mainline for stacked-up traffic, and later to clean up the rest of the wreckage and assess damage. (Courtesy of Conneaut Historical Railroad Museum.)

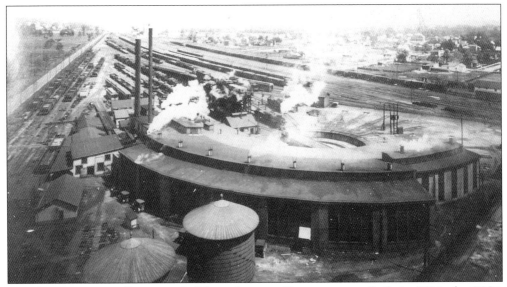

THE PENNSYLVANIA RAILROAD'S WEST AVENUE ROUNDHOUSE. Built in 1906, the PRR's roundhouse was one of two located near to each other on West Avenue. The other served the New York Central. A large part of this structure survives today as a metal scrapyard office. (Courtesy of Ashtabula County District Library.)

THE NEW YORK CENTRAL'S WEST AVENUE ROUNDHOUSE. Things are "cooking" at the busy roundhouse and car shops, to judge by the many smokestacks and vents which are going at full capacity. (Courtesy of Conneaut Historical Railroad Museum.)

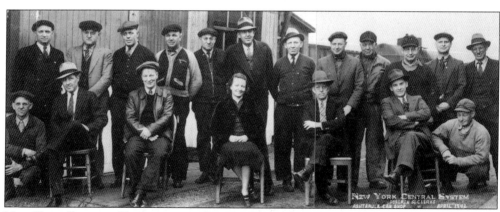

NEW YORK CENTRAL FOREMEN AND CLERKS AT THE ASHTABULA CAR SHOP IN APRIL 1942. (Courtesy of Ashtabula County District Library.)

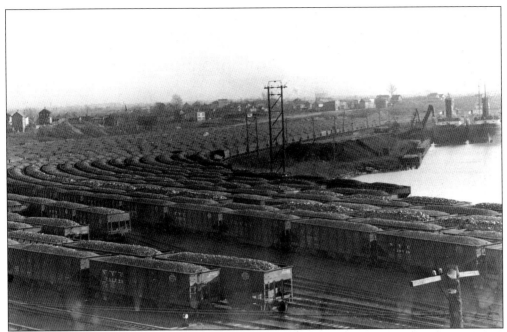

COAL AS FAR AS THE EYE CAN SEE. The vastness of the railroads' coal-hauling operation in the early 1940s is evident in this splendid photo looking south along the New York Central's tracks. (Herbert Satterlee photo, courtesy of Ashtabula County District Library.)

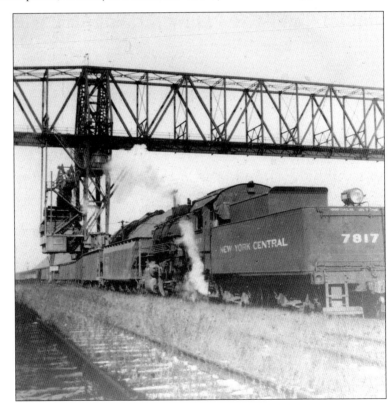

LINING UP CARS FOR THE COAL LOADER, NYC DOCKS. A switcher shoves a cut of coal hoppers. (Courtesy of Conneaut Historical Railroad Museum.)

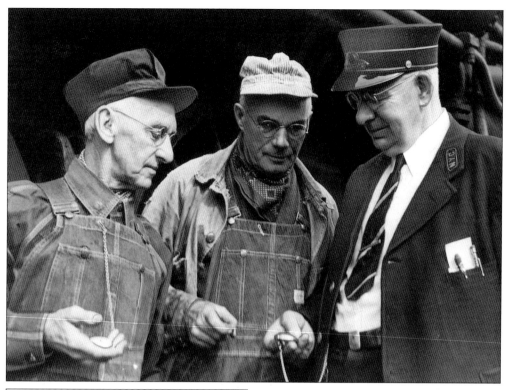

RAILROADERS ON OCTOBER 4, 1941. Pearl Harbor lies just ahead, and these Ashtabula employees of the New York Central will play their part in the railroad's massive troop and materials hauling in aid of the war effort. Left to right: Engineer Lou Graham, engineer Jack Halloran, conductor Bill Ellis. (*Cleveland Press*, Special Collections, Cleveland State University Library.)

BILL GLASS, ENGINEER ON THE NEW YORK CENTRAL. A local resident and frequent operator of the prestigious 20th Century Limited passenger train, Glass is photographed here in the cab of a 2-8-2 "Mikado" of class H-10a, built by Alco in 1922–1923. The Water Level Route, which passed through Ashtabula, was much longer in track miles than the Pennsylvania's direct route up and over the Alleghenies via Horseshoe Curve, yet because the Central could achieve better speeds on the level track both railroads made about the same time with their fastest trains between Gotham and the Windy City. (Eleanor and Lawson Stevenson Collection.)

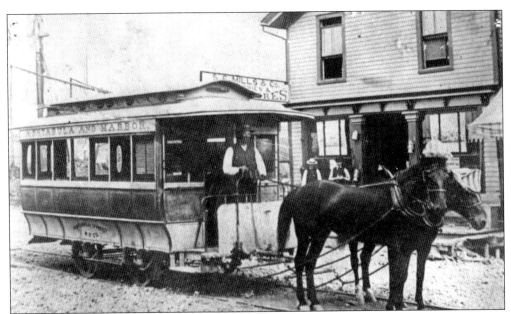

STEWART HORSE CAR LINE, BRIDGE STREET AT MORTON DRIVE, 1888. The earliest trolleys, before overhead electric wires were installed, were pulled by horses. (Petros Collection.)

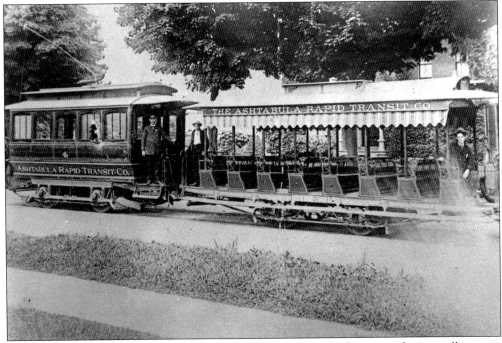

ASHTABULA RAPID TRANSIT COMPANY. The company, which operated city trolleys, was founded in 1892. Beginning in 1938, following a nationwide trend, the trolley lines were sadly abandoned in favor of buses, bringing to an end a clean, economical and gracious mode of travel. (Courtesy of Conneaut Historical Railroad Museum.)

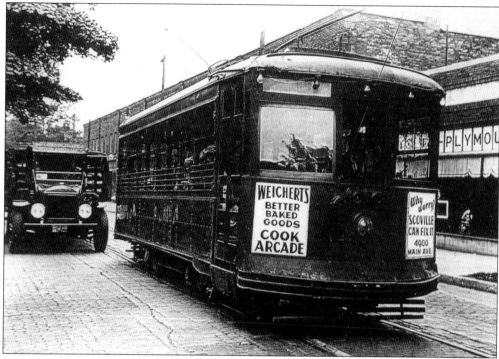

STREETCAR IN 1932, LOOKING WEST ON CENTER STREET. (Courtesy of Ashtabula County District Library.)

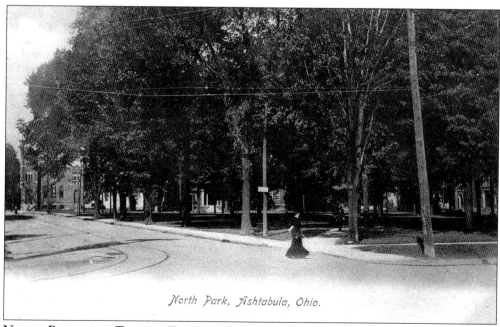

North Park, Ashtabula, Ohio.

NORTH PARK WITH TROLLEY TRACKS. The rails and overhead wires lend their charm to a classic postcard view of the park. (Borsvold Collection.)

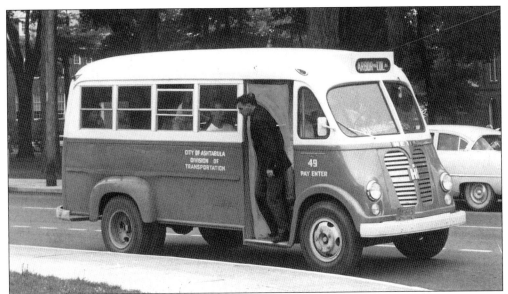

SPRUCING UP PUBLIC TRANSIT. Buses followed trolleys, but lacked their romance. One of the city's new "jitney" buses is seen in this view from September 7, 1961. The city of Ashtabula has not run buses on a continuous basis since the 1960s, and today there is only a limited amount of bus service, provided by the county. (*Cleveland Press*, Special Collections, Cleveland State University Library.)

NICKEL PLATE R. R., BY NIGHT, ASHTABULA, OHIO.

NICKEL PLATE MINIATURE POSTCARD. The Nickel Plate Railroad (New York, Chicago, and St. Louis) did not serve the Harbor, but its mainline ran just north of the South Ridge, parallel to that of the New York Central. The Nickel Plate had a major roundhouse and yard in Conneaut. It was absorbed in 1964 by the Norfolk & Western, which merged with the Southern Railway in 1982 and became Norfolk Southern. (Courtesy of Ashtabula County District Library.)

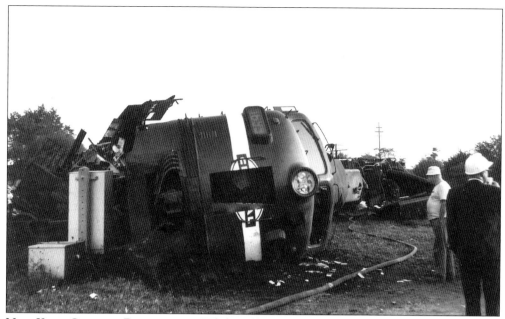

NEW YORK CENTRAL DERAILMENT. While pulling a freight train, the lead unit, F7 No. 1699 (built in April 1941), has jumped the rails. Believe it or not, this locomotive would be repaired and returned to service. (Courtesy of Ashtabula County District Library.)

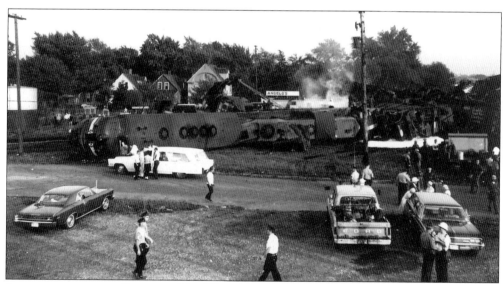

INVESTIGATION AND CLEANUP. The F7 and a trailing GP7 (or GP9) will be in the shop for repairs for some time. It was the "F" units, made in great quantities by the Electro-Motive Division of General Motors, that were most responsible for knocking steam power off American railroads. Not only was diesel maintenance much cheaper, but multiple-unit (MU) cables allowed a single crew to run several engines at once, something impossible with steam locomotives. (Courtesy of Ashtabula County District Library.)

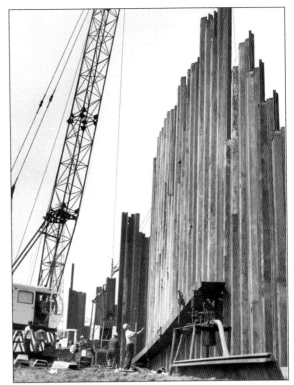

A New Car Dumper for the PRR, June 1967. Bitter rivals for many decades, the Pennsylvania Railroad and the New York Central had been in merger talks during much of the 1960s. By the time this sheet piling was erected, the merger was a reality and both roads would disappear into the new Penn Central in less than six months' time. The soon-bankrupt PC was absorbed by Conrail in 1976, and Ashtabula dock rights were conveyed in turn to Norfolk Southern at the end of the century with the breakup of Conrail and its parceling out between NS and CSX. (*Cleveland Press*, Special Collections, Cleveland State University Library.)

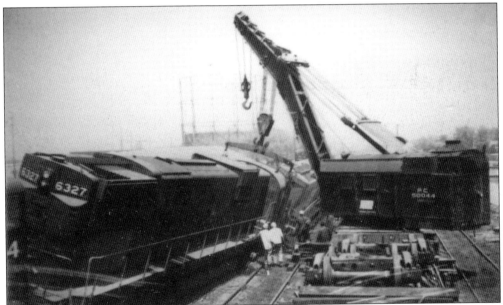

Penn Central Derailment on September 23, 1968. A PC crane prepares to lift lead unit 6327, a hulking Alco C-630 (formerly owned by the Pennsylvania), in the early months of the disastrous merger between the PRR and the NYC. Beset with a myriad of problems including redundant routes, nonexistent system-wide communication or cooperation, and ruinous investments, the Penn Central was *itself* a train wreck. Conrail would clean up the mess beginning in 1976. (Courtesy of Ashtabula County District Library.)

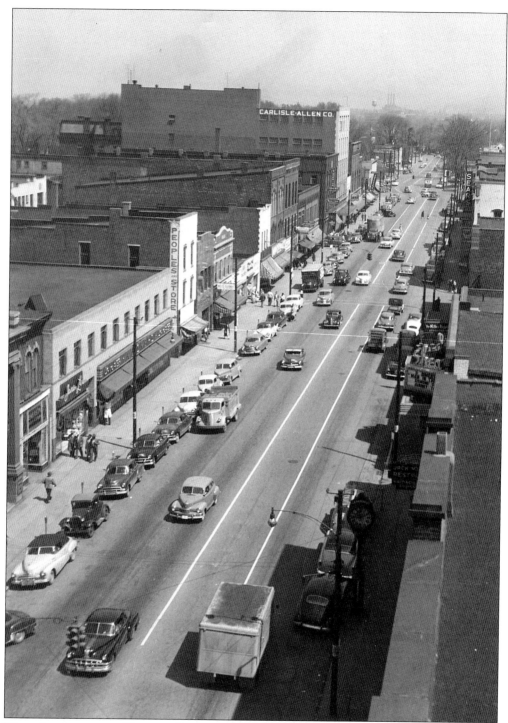

MAIN AVENUE IN ITS HEYDAY, PHOTOGRAPHED ON MAY 8, 1953. Like so many American downtowns, Ashtabula's was soon to face tremendous challenges posed by sweeping changes in Americans' shopping and travel habits. (*Cleveland Press*, Special Collections, Cleveland State University Library.)

Three

A GALLERY OF
ASHTABULA IMAGES

Ashtabula, like many an American city, possessed a number of historic and elegant buildings, some of which have survived and others of which were destroyed (wisely or not). Urban Renewal was a mixed blessing at best, in any city. The next generation is often quick to replace what their parents had with what at the time appears to be modern, new and efficient, but valuable architectural treasures such as Ashtabula's Sovinto Hall can thus be lost to future generations. If restoring or preserving classic structures seems wiser today than replacing them with bland, uninspired "box" stores and parking garages, this was not the case in the 1960s.

Fortunately, Ashtabula still possesses a large number of beautifully constructed buildings and homes. Some—most notably the Hotel Ashtabula—still await renovation, but others have been restored in a way which recalls the city's glory days and might lead the way for more preservation efforts. This chapter will survey old and new photos of buildings, civic works, bridges, and the like.

In addition, the photos of Ashtabula citizens will tell the story of many different periods in the city's history.

HUBBARD HOUSE, BUILT AROUND 1841, THE HOME OF WILLIAM AND CATHARINE HUBBARD. The house's location, uphill from Walnut Beach and the Harbor, was perfect for its secret purpose: serving as a northern terminus of the Underground Railroad, an alliance of people devoted to assisting slaves' flight to freedom. Code-named "Mother Hubbard's Cupboard" or "The Great Emporium," the house was a haven for slaves who were waiting for cover of night to sail for Canada. Citizens routinely flouted the Fugitive Slave Act by hiding and transporting slaves, not one of whom was ever recaptured in Ashtabula County. Hubbard House, listed on the National Register of Historic Places, is now an important museum devoted to the Underground Railroad. (Borsvold Collection.)

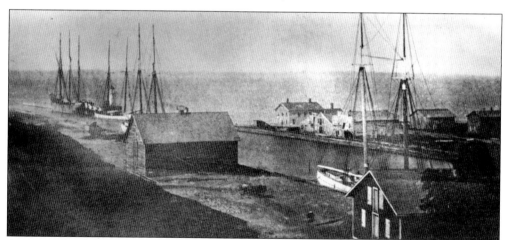

ASHTABULA HARBOR IN THE YEAR OF THE RAILROAD'S ARRIVAL, 1873. The original lighthouse is seen behind the schooners at left. On the east (right) bank of the river are Morey's Hotel, Humphrey's Grocery, Seymour's warehouse, and Willard and Well's warehouse. Under the tree on the west bank was the Old Yellow Warehouse of Hubbard & Company, a freight forwarding operation run by Henry Hubbard and his brother-in-law Joseph Dewey Hulbert. A few years earlier, slaves awaiting the summons to stow away in the forecastle of a departing vessel had often been hidden in this warehouse, behind freight piles or stacks of lumber. (Courtesy of Ashtabula Marine Museum.)

BLAKESLEE LOG CABIN. Built in 1810 by Asher and John Blakeslee, this authentically preserved pioneer home is located at the Rt. 11–Seven Hills Road interchange in Plymouth Township (formerly part of Ashtabula). Kept in superb condition by members of the Ashtabula County Historical Society and other dedicated volunteers, the house is opened regularly for pioneer-oriented historical programs for students and adults. "Log Cabin Days" in September are a pioneer festival with demonstrations, music, and food. (Courtesy The Blakeslee Log Cabin.)

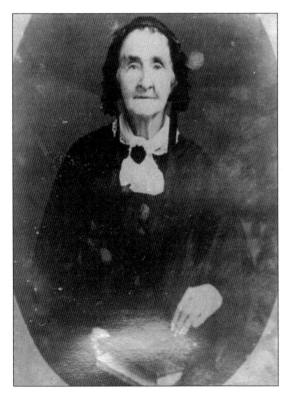

ARSENATH BLAKESLEE (1807–1891). She married into the Hubbards, strengthening ties between the families. The Blakeslees, organizers of the first Episcopalian parish in Ohio, were closely associated with the Hubbard family and may have participated in the Underground Railroad, although this cannot be documented due to the secrecy necessary in those days. (Courtesy The Blakeslee Log Cabin.)

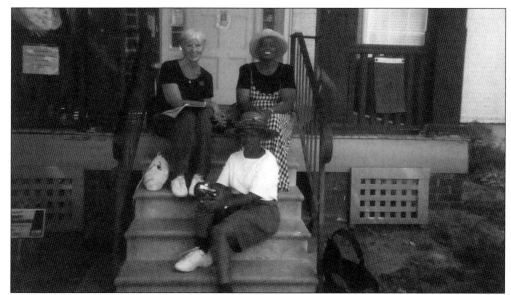

Reception for Joan Southgate at Hubbard House, September 7, 2002. Beginning on Easter Sunday 2002, Ms. Southgate, a Clevelander whose mother and grandmother knew the legendary Harriet Tubman, undertook a walking journey to retrace the steps of escaped slaves along the Underground Railroad. She planned to resume her trek in Spring 2003 by walking from Edinboro, PA, to St. Catherines, Ontario. Clockwise from top: Irene Bent, Daisy Baskerville, Joan Southgate. (Daisy Baskerville Collection.)

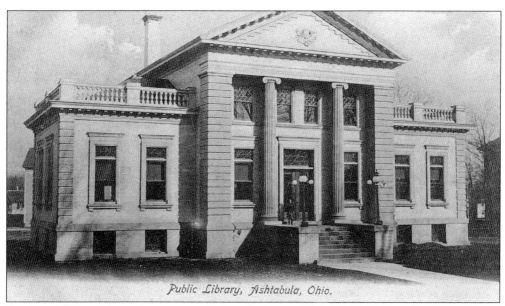

Public Library, Ashtabula, Ohio.

Postcard View of the Ashtabula Public Library. The successor to a subscription library association begun in 1813, this library was built in 1903 with funds from Andrew Carnegie. A change in Ohio library law allowed it to become a county district library in 1953. Several renovations have been done over the years, most recently in 1992. With a much-changed roofline and a glassed-in addition through which patrons enter, the Ashtabula County District Library continues to serve city residents today. (Borsvold Collection.)

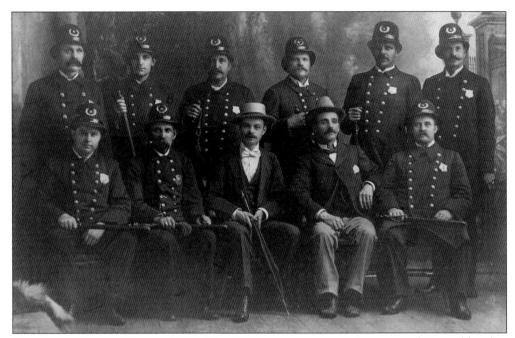

THE EARLY POLICE FORCE, 1898. The department grew out of a group of Constables that patrolled the area from 1881 until 1891, when the city was incorporated. Beginning in 1904, the department formally followed Ohio Civil Service rules for hiring and promotion. (Courtesy of Hubbard House.)

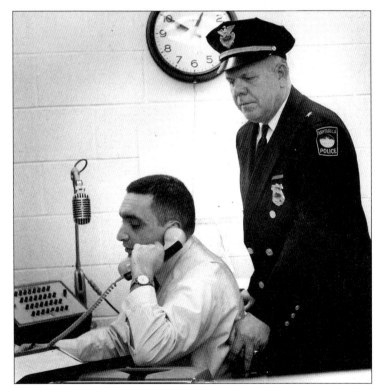

MODERNIZING THE FORCE. The Police Department underwent considerable growth in manpower and resources in the 1960s, adding hand-held radios, radar, a crime and photo lab, and a new base and mobile radio system. Police Chief Gordon Arvidson is here shown in City Hall with dispatcher Tony Giangola on November 18, 1965. (*Cleveland Press*, Special Collections, Cleveland State University Library.)

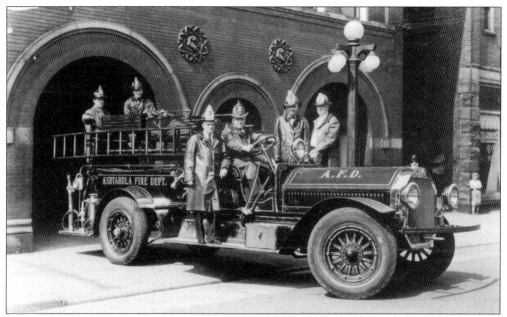

THE ASHTABULA FIRE DEPARTMENT AT THE BRIDGE STREET STATION, c. 1910–1915. The department was founded in 1836 when the village purchased a fire engine, built a small structure, and organized monthly drills. Prior to becoming a professional department it consisted of eight volunteer companies consisting of 18 men each. In 1911, the Ashtabula Fire Department staff became full-time paid employees, and on January 22, 1919 the men decided to organize and join the IAFF, becoming Local 165. (Courtesy of Ashtabula County District Library.)

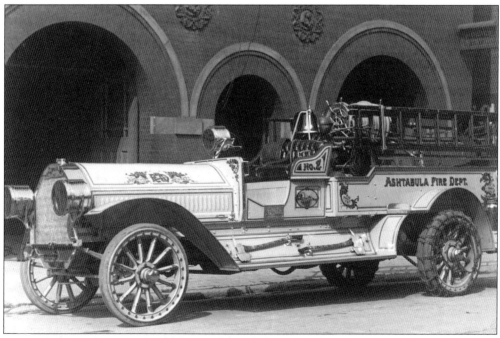

NEW 1913 STERLING FIRE TRUCK WITH SOLID RUBBER TIRES. (Courtesy of Ashtabula Marine Museum.)

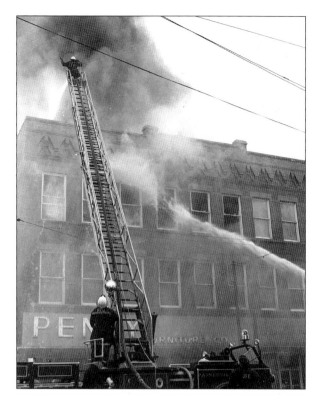

(*top left*) **PATRIOTISM ON VIEW.** On June 26, 1963, the flag at the West 9th Street fire station is ready for the Fourth of July celebrations. The bell was formerly on top of the Harbor police and fire station on Bridge Street. (*Cleveland Press*, Special Collections, Cleveland State University Library.)

(*top right*) **THE ASHTABULA FIRE DEPARTMENT IN ACTION, 1965.** The Penny Furniture Company fire was an example of the difficulties of firefighting in freezing conditions. (Courtesy of Ashtabula Marine Museum.)

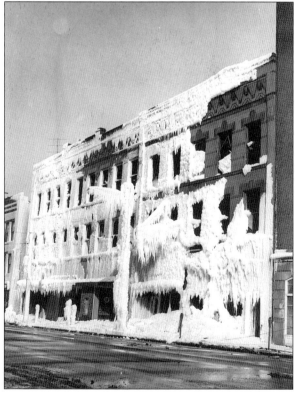

(*bottom right*) **THE ICY AFTERMATH OF THE FIRE.** (Courtesy of Ashtabula Marine Museum.)

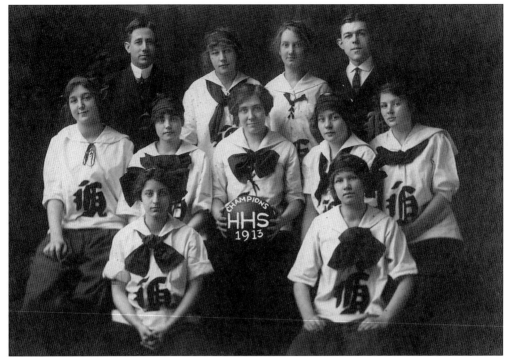

Harbor High School 1913 Girls Championship Basketball Team. (Courtesy of Harbor-Topky Memorial Library.)

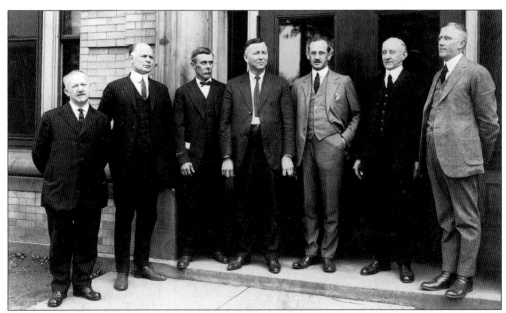

The Harbor School Board in 1922. Pictured from left to right are C.W. Askew, President; H.F. Bugbee, Manager; W.E. Wenner, Superintendent; Oliver C. Topky; John L. Laird; C.H. Brant; and C.O. Gudmundson. Topky, a prominent local businessman, donated money in June 1958 to construct a library in the Ashtabula Harbor area. (Courtesy of Harbor-Topky Memorial Library.)

MILLER BROTHERS MEAT MARKET. This Main Street business is clearly one of the oldest in the district, although this photo is undated. Main Street, rather than Avenue, is used here because it was changed in later years. (Courtesy of Ashtabula County District Library.)

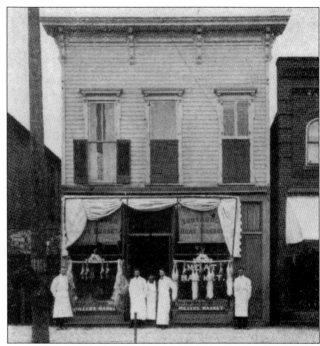

SOVINTO HALL, JOSEPH AVENUE AT WEST 8TH. The largest wooden structure in Ohio was built in 1901 for a Finnish-American cultural center, in part as an alternative to Bridge Street's bars and brothels. The Turva Society, an outgrowth of the late 19th-century temperance movement, merged with the Kuntola Society in 1910 to form the Sovinto (Harmony) Society. The library (in Finnish) and the opera, choir and band performances there, as well as the Hall's athletic teams, were of the highest quality. Its illuminated clock tower, built in Finland, was visible from the Lake. By the 1960s the last member of the old society had died, and this magnificent building was foolishly demolished by the city. (Petros Collection.)

Ashtabula, O.., May 4, 191 5

M Hannah Smith,

Street 504 Lake No.

The D·L·Davis Co.

THE ONLY STRICTLY CASH DEPARTMENT STORE IN ASHTABULA COUNTY

Dry Goods, Ladies' Ready-made Garments

Carpets, Rugs, Dinnerware, Housefurnishings

WE OFFER—*Large and Handsome Assortments, Splendid Quality Merchandise and Rock Bottom Prices.*

WE DO NOT OFFER—Credit. To discriminate, shows partiality, which is hurtful to the store. We ask our friends to co-operate with us by not asking credit, then we can truthfully say we treat all our customers alike.

EARLY 1900S ASHTABULA DEPARTMENT STORE RECEIPT. (Courtesy of Ashtabula County District Library.)

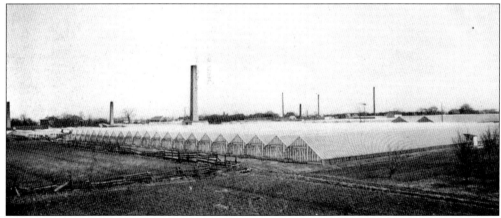

GREENHOUSE CAPITAL. The lakeside climate is perfect for the growing of many varieties of plants, and in 1928 Ashtabula was the nation's largest greenhouse area, with 88 covered acres. The Depression took a toll on smaller growers, many others eventually retired or moved their operations elsewhere, and today about one-tenth of the greenhouses remain, even fewer under glass. (Courtesy of Harbor-Topky Memorial Library.)

THE KIMBLE SHEET METAL WORKS
IN OCTOBER, 1923. The photographer
has smartly put a sign with the date on
the front stoop! (Courtesy of Ashtabula
County District Library.)

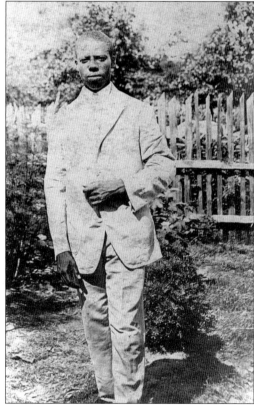

TITUS MILLER, PHOTOGRAPHED c. 1917.
In 1944, living in Louisville, Mississippi
and seeking a better life and education
for his family, Miller responded to an
advertisement for jobs in Ashtabula.
He took a job at Electromet and many
people from his home area followed. This
movement was part of a large migration of
African-American workers to Ashtabula at
the end of World War II. (Daisy Baskerville
Collection.)

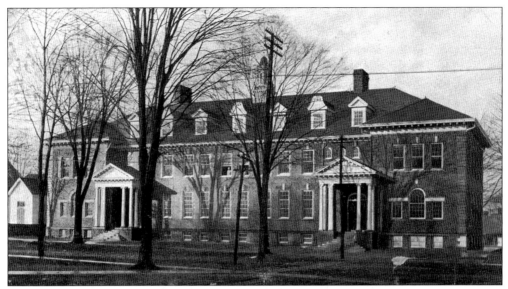

HIGH SCHOOL ASHTABULA. Built in 1900 and dedicated in 1902, it became Park Street Junior High when Ashtabula High School opened in 1916. The building was abandoned in January 1957, but Kent State University–Ashtabula Campus began using it a year later. (Courtesy of Hubbard House.)

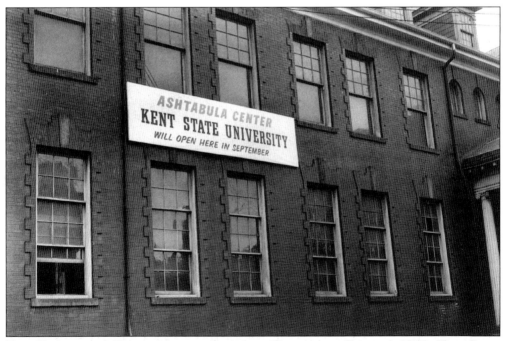

THE OLD SCHOOL, READY FOR THE START OF UNIVERSITY CLASSES, 1958. Kent State-Ashtabula used the facility for classes until 1967, when its own new campus opened. The school served concurrently as the headquarters for the Ashtabula (later Northeast) Technical School, until it became part of the University. The 28,000-square-foot building was listed on the National Register of Historic Places on January 1, 1975, but it burned down on the morning of September 7, 1975. (Courtesy Kent State University, Ashtabula.)

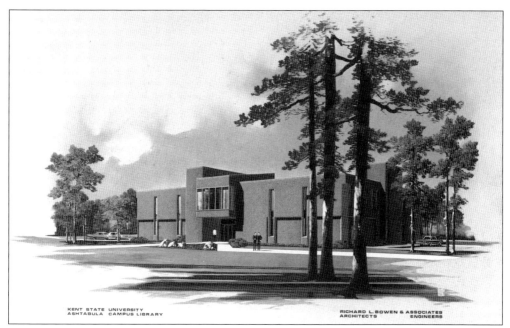

ARCHITECT'S DRAWING FOR THE KENT STATE ASHTABULA LIBRARY. (Courtesy Kent State University, Ashtabula.)

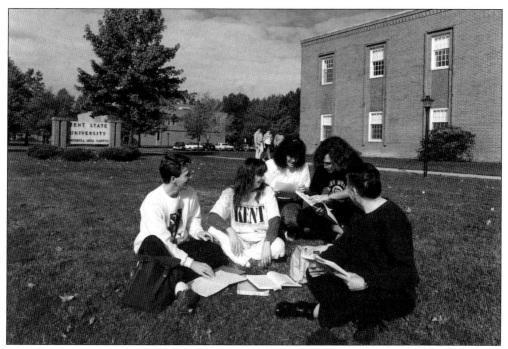

KSU STUDENTS SHORTLY AFTER THE OPENING OF THE CAMPUS. Today more than 1,300 students, young and old, are enrolled. Bachelor's degrees are available in business, general studies, justice studies, nursing, and technology. Fifteen associate degrees can be earned, and the first two years of any of the 181 Kent State University fields of study may be completed at the Ashtabula branch. (Courtesy Kent State University, Ashtabula.)

ASHTABULA
Going Forward

BUILDING HOMES

CULTURAL, EDUCATIONAL
and RECREATIONAL

NEEDS TO SERVE A GROWING
INDUSTRIAL COMMUNITY

POPULATION 35,000 BY 1950

For Information

Telephone 2464

ASHTABULA
CHAMBER OF COMMERCE

4626 MAIN AVENUE

ASHTABULA CITY DIRECTORY (1946)

POSTWAR ADVERTISEMENT BY THE CHAMBER OF COMMERCE. Industrial prospects were sky-high after World War II, and this 1946 telephone book ad demonstrates the optimism of the city and the nation in that boom era. (Courtesy of Harbor-Topky Memorial Library.)

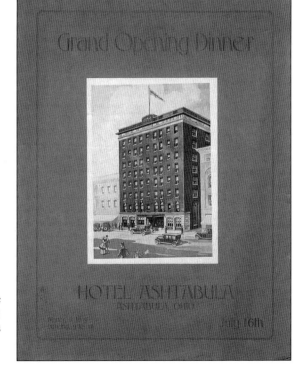

PROGRAM FROM THE OPENING OF THE HOTEL ASHTABULA. The English-designed Georgian hotel, one of Ashtabula's grandest landmarks, opened in 1920 and is currently on the National Register of Historic Places. It has not yet been renovated, and stands vacant. (Courtesy of Hubbard House.)

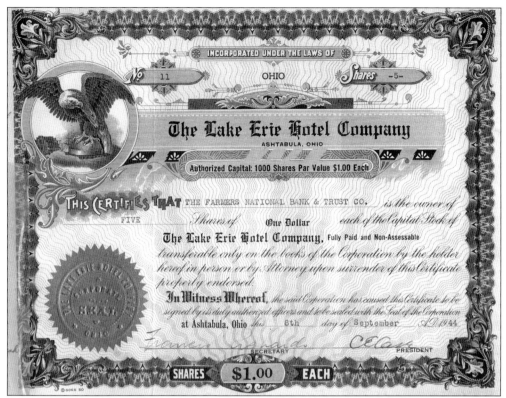

STOCK CERTIFICATE FROM THE HOTEL ASHTABULA. (Courtesy of Hubbard House.)

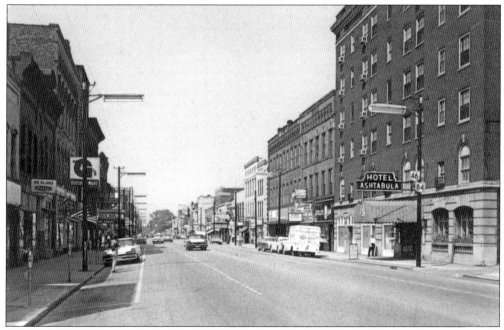

THE HOTEL ASHTABULA IN THE LATE 1950S. This postcard also shows Main Avenue, still busy in this era. (Courtesy of Hubbard House.)

PALACE ASHTABULA —OHIO— ADMIT ONE Price 50 Cents

Ashtabula Harbor Alumni presents

The Harbor High Band

In a Special Benefit Concert

Under the Direction of Mr. Geo. H. Wahlstrom

Tuesday and Wednesday, May 10 & 11

Offering a Special Repertore
as the Introduction of Their Program in
The State Band Contest

2 Concerts
Every Nite
7:00 & 9:30

SHOWING THE REGULAR FEATURE PHOTOPLAY, PRESENTING

"Hills of Kentucky"
STARRING
RIN-TIN-TIN
WITH
JASON ROBARDS

WARNER BROS. PRODUCTION

ALSO SHOWING A Surprise Program of SHORT SUBJECTS

HARBOR HIGH SCHOOL CONCERT TICKET. (Courtesy of Harbor-Topky Memorial Library.)

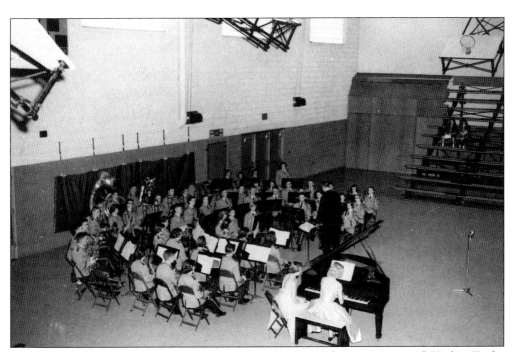

HARBOR HIGH SCHOOL BAND CONCERT, UNDATED. (Photo courtesy of Harbor-Topky Memorial Library.)

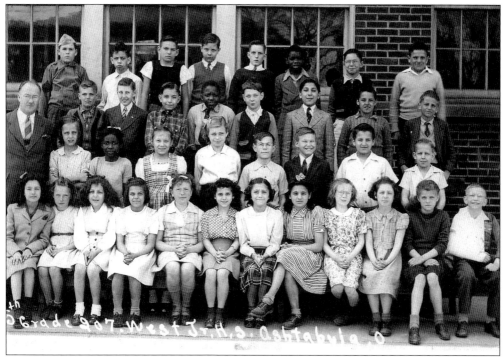

FIFTH-GRADE CLASS AT WEST JUNIOR HIGH SCHOOL IN THE 1930S OR '40S. (Borsvold Collection.)

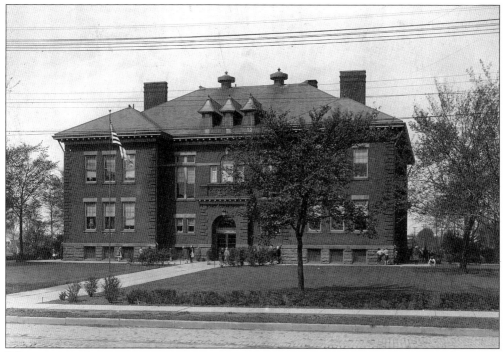

WASHINGTON SCHOOL, BUILT IN 1904, PHOTOGRAPHED ON FEBRUARY 12, 1941. (Courtesy of Harbor-Topky Memorial Library.)

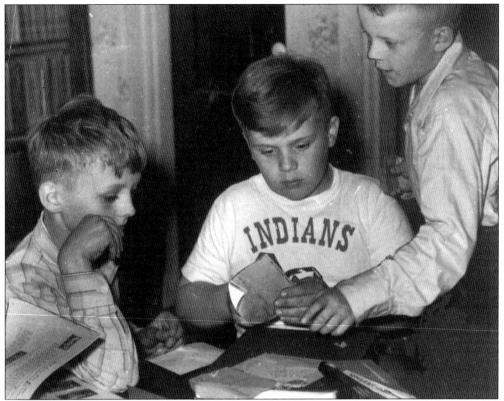

THE STAMP CLUB AT HARBOR LIBRARY IN 1950. These boys certainly seem excited to share their hobby, long before the age of video games and radio controlled cars. (Courtesy of Harbor-Topky Memorial Library.)

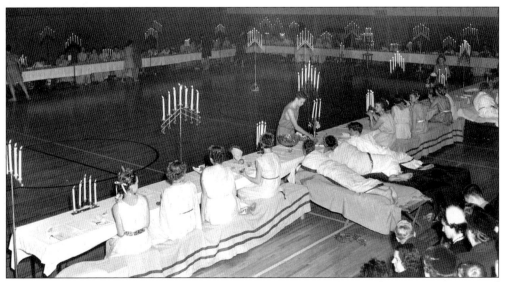

THE ROMAN BANQUET AT HARBOR HIGH. This biennial historical event was organized by the Latin Club at Harbor High School in the late 1940s and early 1950s. (Courtesy of Harbor-Topky Memorial Library.)

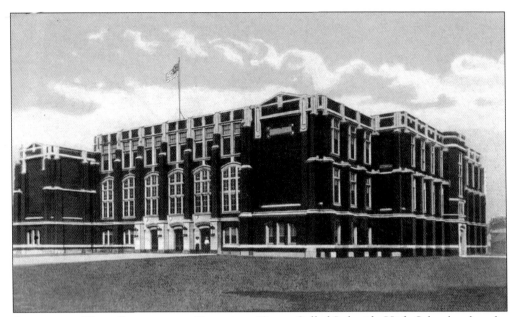

ASHTABULA HIGH SCHOOL IN A POSTCARD VIEW. Called Lakeside High School today, the building stands next to the downtown Library. In 2002 a crucial levy was passed, securing three-to-one state matching funds for the construction of a new high school that will serve students from Ashtabula, Saybrook, and Plymouth. (Borsvold Collection.)

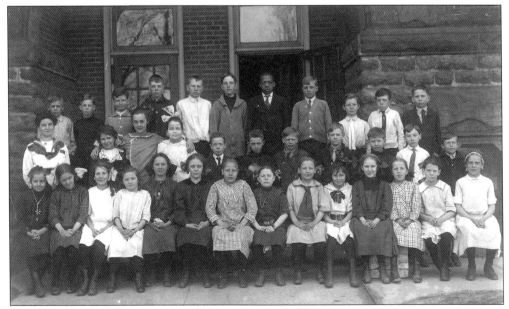

THE JACKSON SCHOOL CLASS OF WINONA THOMAS. The school was demolished in 1972 after 82 years of service. Undated photo. (Courtesy of Harbor-Topky Memorial Library.)

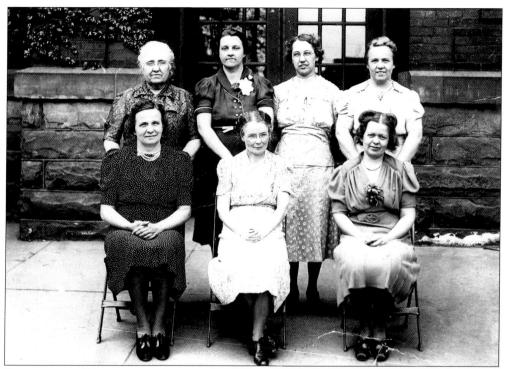

TEACHERS AT WASHINGTON SCHOOL, ABOUT 1930. The principal is at upper left. (Courtesy of Harbor-Topky Memorial Library.)

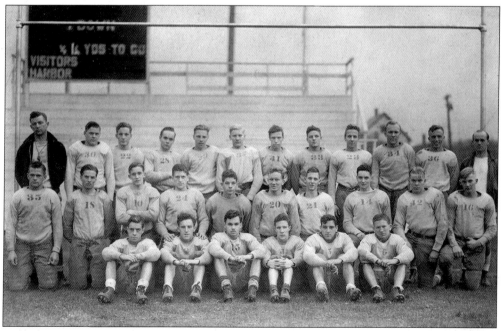

THE HARBOR HIGH 1932 FOOTBALL TEAM. (Courtesy of Harbor-Topky Memorial Library.)

POSTCARD OF THE OLD YMCA BUILDING. Much missed by local residents since it was demolished in the 1970s, this building, which was located on Park Avenue at Progress, is spoken of wistfully by older citizens today. (Courtesy of Ashtabula County District Library.)

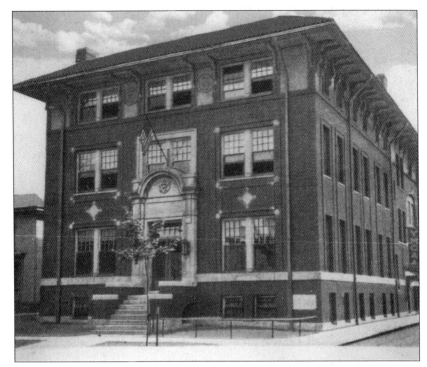

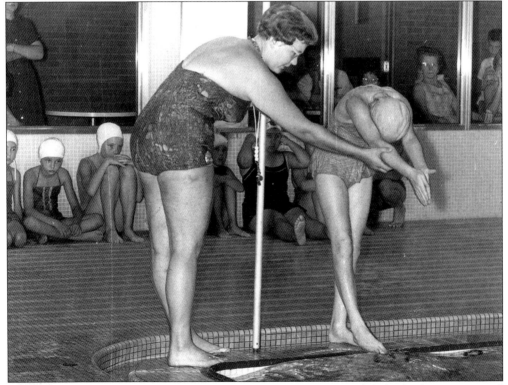

SWIMMING LESSON AT THE OLD YMCA, AUGUST 14, 1963. (*Cleveland Press*, Special Collections, Cleveland State University Library.)

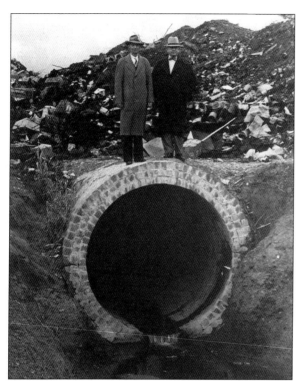

RELIEF FOR WEST SIDE FLOODING. City Manager W. H. Flower and City Engineer C. R. Stanhope pose at the mouth of the Strong Brook Storm Sewer, the largest in Ashtabula County, on November 9, 1939. Tunneled through solid rock and underneath several railroad tracks, the large pipe drained the west side of the city, ending sewer backups and the flooding of many cellars. (*Cleveland Press*, Special Collections, Cleveland State University Library.)

MEMORIAL ANNOUNCEMENT, OUR LADY OF MT. CARMEL CHURCH, 1952. The religious traditions of Ashtabula are as rich and diverse as the ethnic groups that arrived looking for work over many decades. (Courtesy of Ashtabula County District Library.)

DISC JOCKEY JIM SHARP AND WOMEN'S PROGRAM DIRECTOR PAT SHARP IN THE STUDIO AT RADIO STATION WICA, MAY 8, 1953. WICA was a predecessor to today's WFUN. Note the 78 rpm disc on the turntable! (*Cleveland Press*, Special Collections, Cleveland State University Library.)

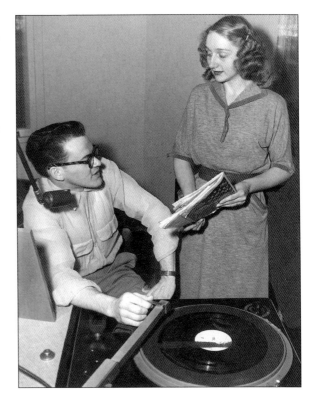

SESQUICENTENNIAL FUN. In 1953, for Ashtabula's 150th anniversary, the Chamber of Commerce sponsored a contest, entitled "Brothers of the Brush," for the best "period" beard. (*Cleveland Press*, Special Collections, Cleveland State University Library.)

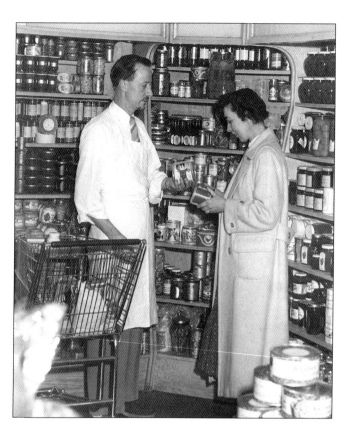

CHARLES MOSES, GROCER AND LOCAL HISTORIAN. In this photo from May 8, 1953, Moses visits with Mrs. Stephen Poros in the Moses Food Store on State Road. Born and raised in Ashtabula, he purchased the grocery in 1936. After his death in 1990, his wife and daughter operated the store as Moses I.G.A. from 1993–96. The refitted building was reopened as the Moses Antique Mall on April 1, 1997, and is run by daughter Jane Moses. In the 1950s, inspired by the interest of his wife, Jane Anderson, Moses became an avid collector of antiques and memorabilia. Portions of the Charles Moses Americana Collection are on display at Hubbard House today. (*Cleveland Press*, Special Collections, Cleveland State University Library.)

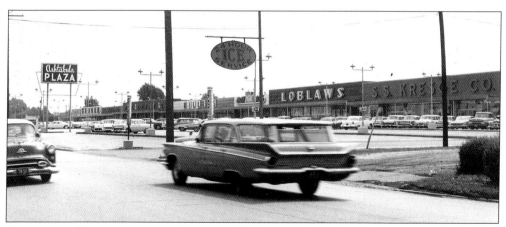

ASHTABULA PLAZA ON LAKE AVENUE. While viewed at the time as an enticement to shoppers, the Plaza and another in Saybrook contributed to the decline of the Main Avenue business district. (*Cleveland Press*, Special Collections, Cleveland State University Library.)

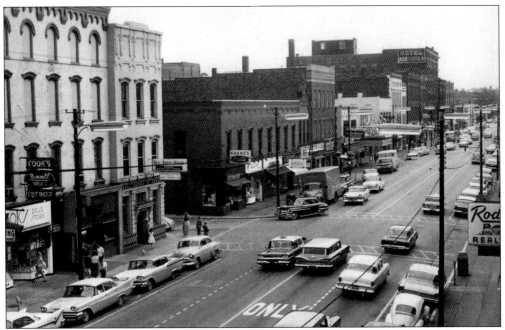

OVERHEAD VIEW OF MAIN AVENUE, SEPTEMBER 7, 1961. An Urban Renewal Plan was being drafted, calling for 15 acres of downtown land to be sold to developers. Main Avenue was to become a walking-street mall with benches and greenery, and with traffic rerouted on Park and Wagner Avenues (the latter extended and renamed Collins Avenue, after a former city engineer). (*Cleveland Press*, Special Collections, Cleveland State University Library.)

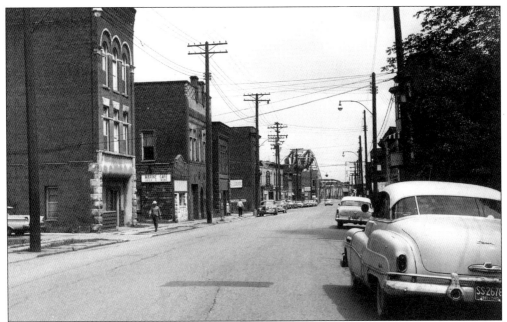

BRIDGE STREET IN 1961. This area too had fallen into decay, and plans were made to begin restoring these historic buildings in the 1970s. (*Cleveland Press*, Special Collections, Cleveland State University Library.)

THE HARBOR-TOPKY MEMORIAL LIBRARY IN THE 1960s. The Library was later expanded and renovated. (Courtesy of Harbor-Topky Memorial Library.)

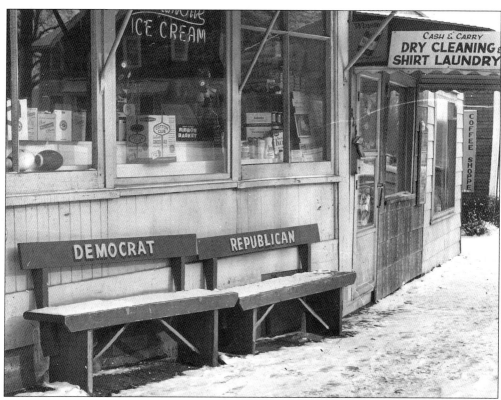

MONTANARO'S BUNKER HILL CONFECTIONARY, MARCH 2, 1961. Management saw to it that political adversaries could enjoy their ice cream, without sitting with the opposition. (*Cleveland Press*, Special Collections, Cleveland State University Library.)

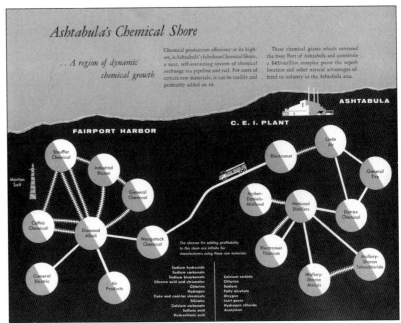

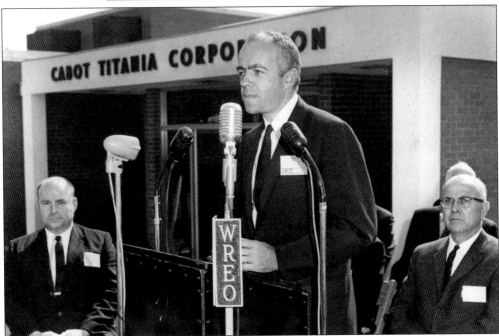

THE CHEMICAL SHORE. On October 10, 1963, Cabot Titania Corporation dedicated its new 20,000-ton-per-year flame chloride process titanium dioxide pigment plant. Louis W. Cabot, president of the Boston-based Cabot Corporation, introduced the operation. Flanked by plant manager Dr. Thomas H. Goodgame (left) and Ashtabula County Commissioners' chairman M.M. Simons (right), Mr. Cabot thanked local industry and government officials, saying that their "outstanding helpfulness in solving many problems has given us an enormous sense of feeling welcome." Cabot Titania later became SCM Corporation, and is now Millennium Inorganic Chemical Company. (*Cleveland Press*, Special Collections, Cleveland State University Library.)

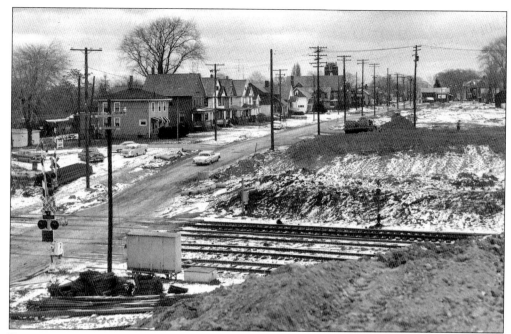

ROUTE 20 GRADE CROSSING. This December 3, 1964 view shows earthwork in place for an overpass to increase motorists' safety at this spot. The crossing was especially hazardous due to the frequent coal or ore trains going in and out of the Harbor along these tracks. (*Cleveland Press*, Special Collections, Cleveland State University Library.)

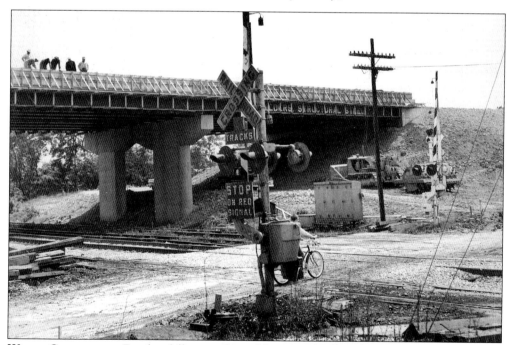

WORK CONTINUES. By the following June 23, crews had made significant progress on the construction of the overpass. (*Cleveland Press*, Special Collections, Cleveland State University Library.)

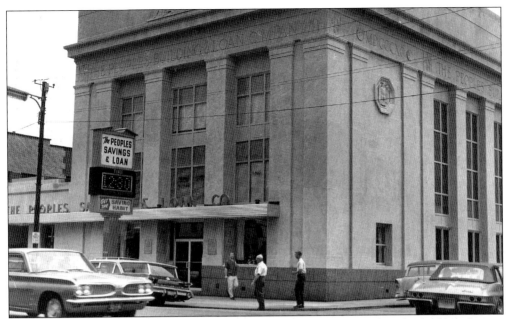

PEOPLE'S SAVINGS AND LOAN BUILDING, AUGUST 15, 1963. Today the building houses the Illuminating Company and several city and county agencies. The time shown on the clock makes this photograph eerily reminiscent of the tragic events in Dealey Plaza in Dallas, which would take place just over three months' time. (*Cleveland Press*, Special Collections, Cleveland State University Library.)

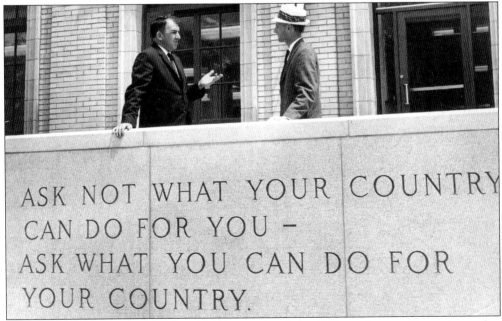

ASHTABULA CITY HALL, JUNE 1965. The words of John F. Kennedy are still on view today, although offices have been relocated and the building is unused at the current time. City Manager David DeLuca is seen at left. (*Cleveland Press*, Special Collections, Cleveland State University Library.)

TWO VIEWS OF ST. PETER'S
EPISCOPAL CHURCH. Here is the
original church, built in 1817 and
soon to be razed, October 31, 1963.
(*Cleveland Press*, Special Collections,
Cleveland State University Library.)

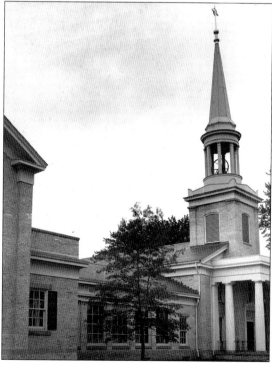

A NEW PLACE OF WORSHIP. The new
St. Peter's Episcopal, photographed
on June 25, 1965. (*Cleveland Press*,
Special Collections, Cleveland State
University Library.)

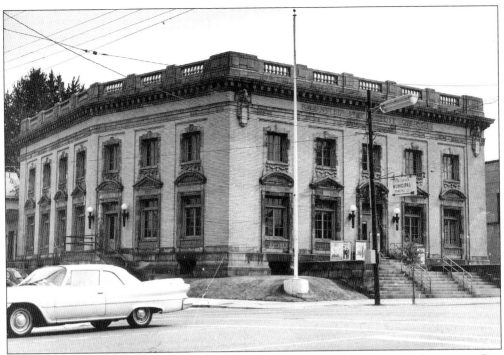

THE OLD POST OFFICE, SEPTEMBER 24, 1964. Soon it would be remodeled as a new City Hall. Hubert Humphrey campaigned for President on the front steps of the building in 1968. (*Cleveland Press*, Special Collections, Cleveland State University Library.)

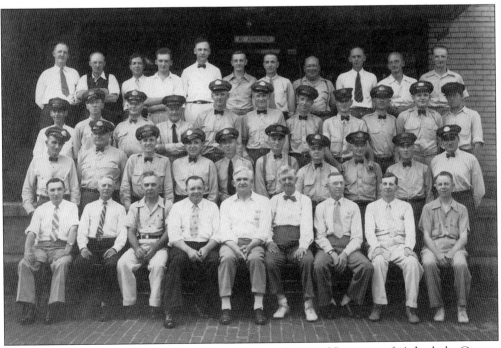

UNDATED PHOTO OF DOWNTOWN POST OFFICE STAFF. (Courtesy of Ashtabula County District Library.)

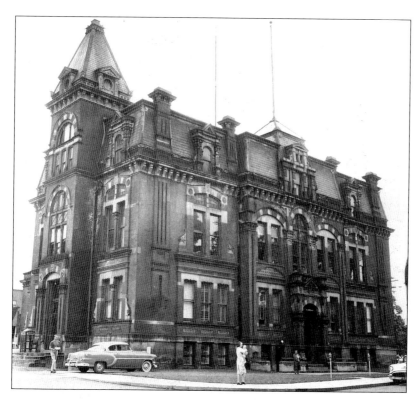

THE OLD ASHTABULA CITY HALL. Located at Main Avenue and West 44th Street, this venerable structure was torn down in 1965. The photograph was taken four years before its demolition. (*Cleveland Press*, Special Collections, Cleveland State University Library.)

REMODELED DOWNTOWN POST OFFICE, THE NEW ASHTABULA CITY HALL, IN THE LATE 1960S. The bare ground between City Hall and the Civil War monument was the site of the old City Hall. (*Cleveland Press*, Special Collections, Cleveland State University Library.)

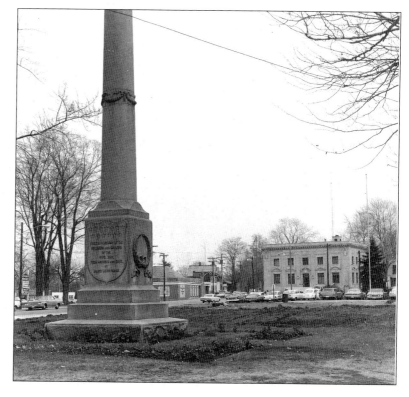

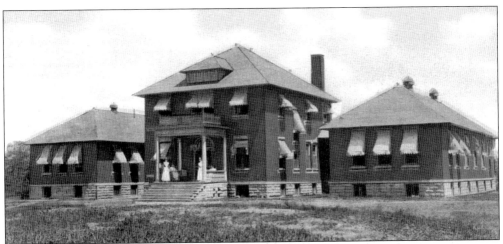

The Old Ashtabula General Hospital, Built in 1904. This original structure began as a railroaders' hospital. A new 150-bed facility (below) would replace it in 1952. (Petros Collection.)

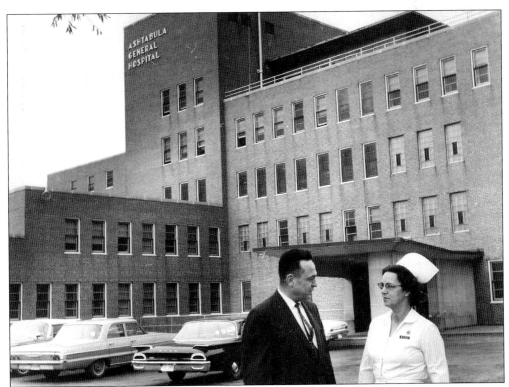

New Ashtabula General Hospital. Hospital administrator George Dubach is shown here on November 2, 1965 with Rose Galovich (later Walters), then director of nurses. A new wing had been added in 1963 to increase capacity to 226 beds. In 1975 a two-story south wing was opened, followed by a reception area and gift shop in 1977. The hospital was reorganized in 1983, and changed its name to the Ashtabula County Medical Center, later becoming affiliated with the world-famous Cleveland Clinic and merging with the Ashtabula Clinic to establish an integrated system in the county. (*Cleveland Press*, Special Collections, Cleveland State University Library.)

HARBOR HIGH SCHOOL, PHOTOGRAPHED ON NOVEMBER 25, 1965. A monument was placed in front of the school, in memory of Ashtabula residents killed in action. (*Cleveland Press*, Special Collections, Cleveland State University Library.)

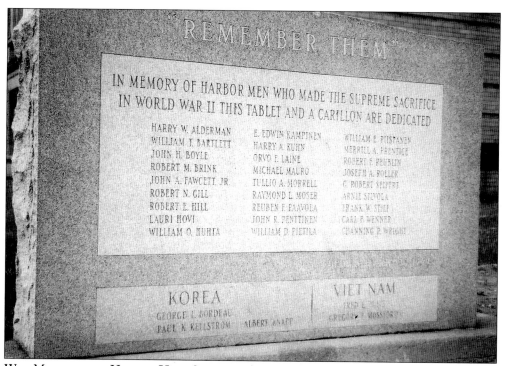

WAR MEMORIAL AT HARBOR HIGH SCHOOL. The monument commemorates three generations of local residents who gave their lives in wartime. (Borsvold Collection.)

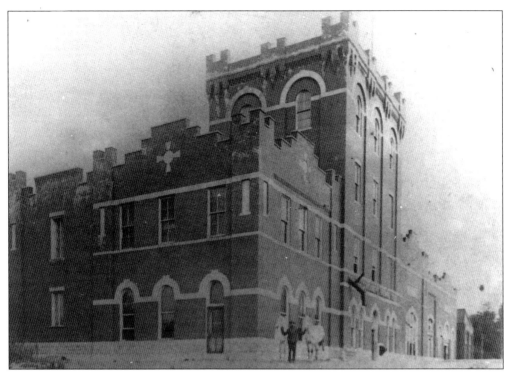

THE ASHTABULA BREWERY. Long gone are the days when every city had its own brew. (Petros Collection.)

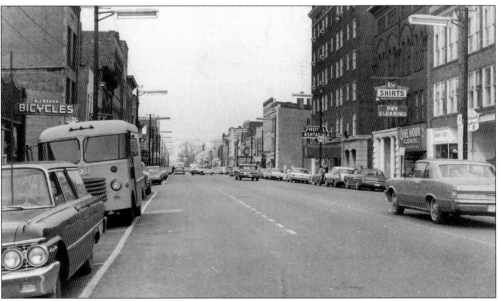

SLOW PROGRESS. A November 1965 view of the section of Main Avenue which was targeted for urban renewal. Developers had failed to materialize, and six local financial institutions joined forces as the Ashtabula Ohio Development Corporation to buy the land. Controversy and difficult times were ahead for downtown. (*Cleveland Press*, Special Collections, Cleveland State University Library.)

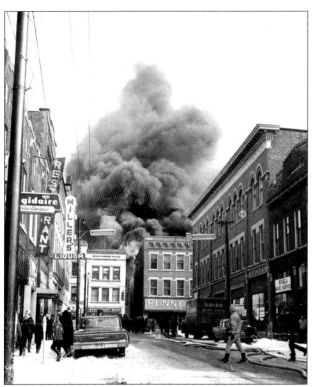

PENNY FURNITURE COMPANY FIRE, MAIN AVENUE, 1965. A devastating winter fire destroyed both the Penny Furniture Company and Clifford Hardware. (Courtesy of Ashtabula Marine Museum.)

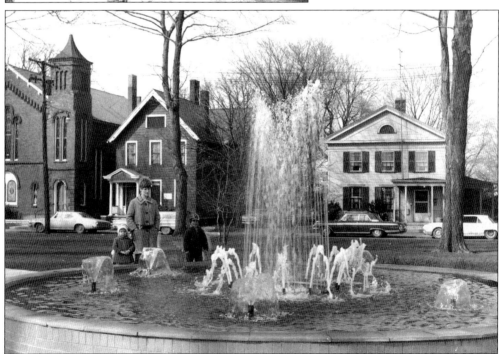

NORTH PARK FOUNTAIN, APRIL 5, 1968. Mrs. Clarence Bortz and her children enjoy the water on a still-cool spring day. (*Cleveland Press*, Special Collections, Cleveland State University Library.)

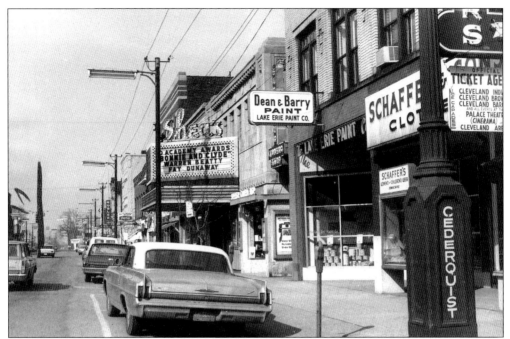

MAIN AVENUE IN APRIL OF 1968. Urban Renewal would soon greatly alter the appearance of the street. The city's historic downtown shopping district had been adversely affected by the completion of Interstate 90 in 1959, which bypassed the city center and allowed quick access to new shopping malls in Mentor and Erie. The 1965 fire further scarred the street. Sweeping changes would soon be made, in an attempt to bring shoppers back downtown. The 1,700-seat Shea's Theatre, built in 1946 and closed in 1973, is a senior center today. (*Cleveland Press*, Special Collections, Cleveland State University Library.)

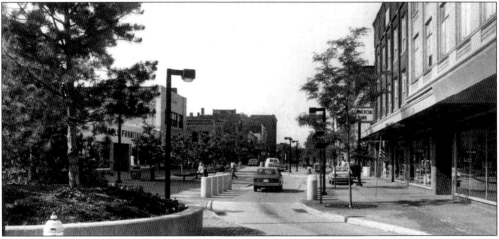

URBAN RENEWAL LEAVES ITS MARK ON DOWNTOWN ASHTABULA. By July 1977, two entire city blocks have been leveled and Main Avenue has been bypassed and closed to traffic. The new pedestrian shopping area and its large parking deck have attracted neither shoppers nor a large anchor store. Eventually the decision to divert traffic was reconsidered, and the street was once again opened to automobiles. (*Cleveland Press*, Special Collections, Cleveland State University Library.)

DUFFER'S OPEN GOLF TOURNAMENT. This tournament, held in Geneva-on-the-Lake, was organized by a group of Ashtabula golfers led by Pete Ball. This photo, taken during the 23rd annual outing, shows, from left to right Stanley Ball, Dale Ball, David Miller, Willie Miller, Shawn Ball, and Roger Ball. (Daisy Baskerville Collection.)

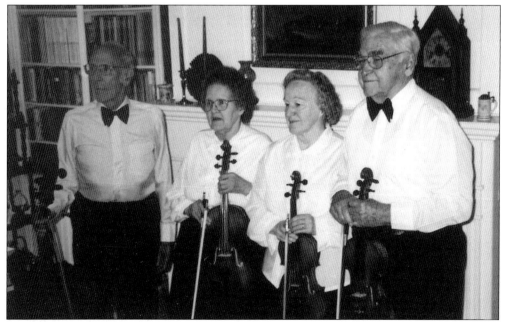

THE LAKE SHORE QUARTET. Made up of members of the Ashtabula Chamber Orchestra (now the Ashtabula Area Orchestra), the group played at many public functions, and although they recently retired from the Orchestra the members still meet on Wednesday mornings for coffee and music-making. Pictured from left to right are Carl Bissell, Eleanor Stevenson, Lois Helman, and Ross Tittle. (Borsvold Collection.)

116

ASHTABULA GREAT LAKES MARINE AND COAST GUARD MEMORIAL MUSEUM. Built in 1898, the Museum was once the residence of the lighthouse keeper and the Coast Guard Chief. The museum's displays include several models, paintings, marine artifacts, an original fresnel-lens lamp from the Ashtabula Lighthouse, photos of early Ashtabula Harbor, ore boats and tugs, fully-functional miniature hand-made brass tools, and a motorized scale model of a Hulett ore unloading machine. (Courtesy of Ashtabula Marine Museum.)

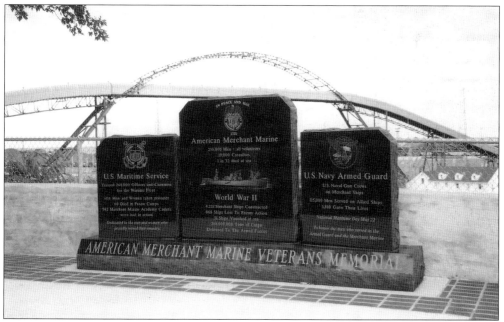

MERCHANT MARINE VETERANS MEMORIAL. This memorial adjacent to the Ashtabula Marine Museum, with the coal conveyor belt as a backdrop, is dedicated to the Merchant Marines, the unsung heroes of World War II. (Borsvold Collection.)

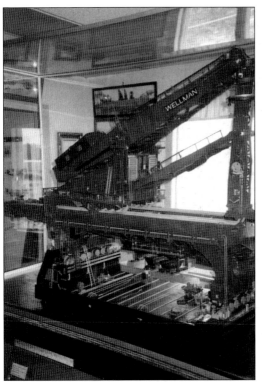

THE WORLD'S ONLY OPERATING MODEL HULETT? Werner Pearson's unique scratchbuilt operating large-scale model of a Hulett Unloader, on display today at the Marine Museum. (Courtesy of Ashtabula Marine Museum.)

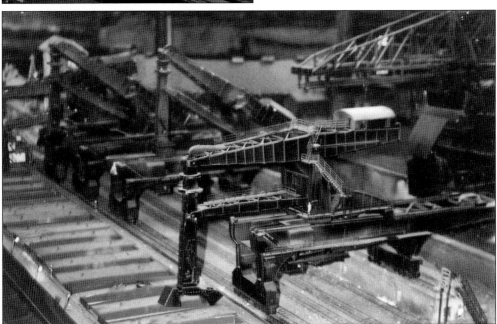

MORE LOCAL MODEL HULETTS. Although Pearson's model is the largest and the only motorized one, he is not the only person to scratchbuild working model Hulett Unloaders. In his extensive HO scale basement train layout, local resident Lawson Stevenson has built four of them. Lawson's recreation of Ashtabula Harbor has been featured three times in *Railmodel Journal* magazine. (Eleanor and Lawson Stevenson Collection.)

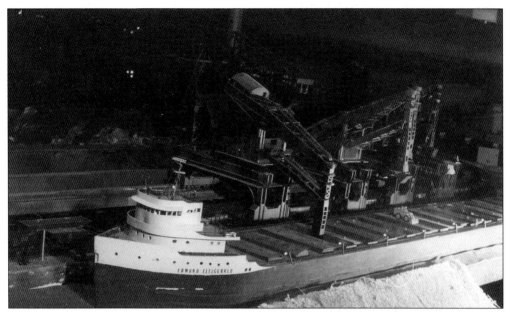

MODEL HULETTS WITH THE EDMUND FITZGERALD. A 5-foot HO scale model of the ill-fated *Fitz*, scratchbuilt by Lawson Stevenson, is unloaded by the four Huletts. When the real *Edmund Fitzgerald* tragically sank in a furious gale on Lake Superior on November 10, 1975, she took with her two Ashtabula sailors, Karl Peckol and Paul Riipa. (Eleanor and Lawson Stevenson Collection.)

CO-FOUNDERS OF THE ASHTABULA GREAT LAKES MARINE AND COAST GUARD MEMORIAL MUSEUM, PAUL PETROS (LEFT) AND DUFF BRACE, 1983. Without their foresight and perseverance, a great many of the photos seen in the pages of this book would never have been collected. (Petros Collection.)

(Borsvold Collection.)

Four

RECESSION, RENAISSANCE, AND THE FUTURE

The latter half of the 20th century brought continual change to Ashtabula. Automated unloading of ships, larger boat capacity, and reduced traffic have brought a much quieter way of life to Ashtabula Harbor, which had previously hosted hundreds of longshoremen and sailors in its bars and restaurants. The 1970s and 1980s were a bleak economic period as many industries closed or relocated, businesses suffered (especially along Bridge Street and in the Main Avenue downtown area), and the finances and services of the city declined. During that time, too, the effect of decades of severe chemical industrial pollution on Fields Brook, the Ashtabula River, and nearby areas of Lake Erie were fully documented, demanding locally-generated solutions.

Due in part to improved economic times, but also to continual effort on the part of local business and community leaders, the 1990s and the present time have seen a quiet and steady renaissance for Ashtabula. The Harbor business district has again become a well-known landmark. A river cleanup effort is underway, although the start of dredging to remove contaminants from the river bottom has been pushed back for now to 2004. The Ashtabula Lighthouse Restoration and Preservation Society, formed in 2001, has a five-year plan in place to acquire and restore the Lighthouse. A July 2002 visit inside the Lighthouse by members of the Society found the structure in better shape than expected, after being vacant for years.

As Ashtabula celebrates its Bicentennial in June 2003, it seems an inescapable conclusion that the appeal of its scenic shoreline and historic neighborhoods will only increase in the near future, as this great lakefront city is rediscovered.

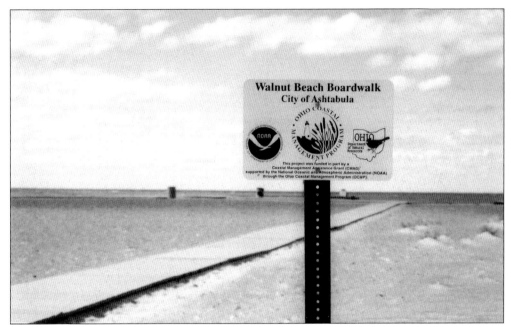

A NEW BOARDWALK FOR WALNUT BEACH. In 1998, Ashtabula received a $15,400 Coastal Management grant for the construction of two boardwalks with wheelchair turnarounds to ensure beach access for everyone. The pathways, made from recycled plastic lumber, connect the beach and the concession stand with the parking lot. (Borsvold Collection.)

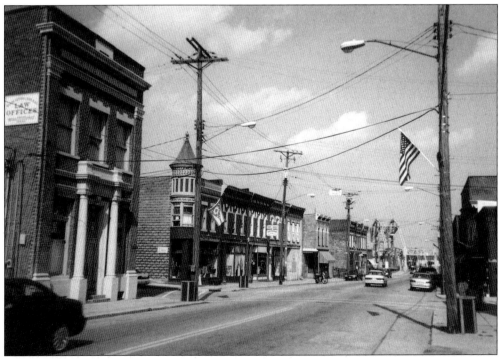

RESTORATION ON BRIDGE STREET. The Marine Bank (now a law office) and other renovated buildings on the city's tourist way in 2002. (Borsvold Collection.)

GROUNDBREAKING FOR THE RENOVATION AND EXPANSION OF HARBOR-TOPKY MEMORIAL LIBRARY, MAY 11, 2000. (Courtesy of Harbor-Topky Memorial Library.)

SUBSEQUENT CONSTRUCTION ON THE WEST SIDE OF THE LIBRARY. (Courtesy of Harbor-Topky Memorial Library.)

JUSTICE CENTER. Recession, population decrease, and federal funding difficulties in the 1980s were hard on the Ashtabula Police Department, forcing layoffs and service cuts, but an economic rebound in the 1990s allowed for new hirings and the construction of a new Jail and Justice Center. (Borsvold Collection.)

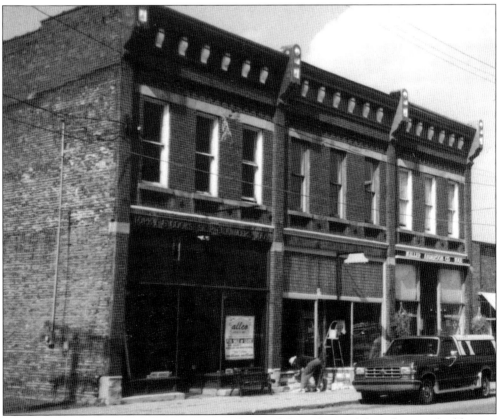

RENOVATION ON BRIDGE STREET, 2002. The need for upkeep of these historic buildings is continuous. (Borsvold Collection.)

124

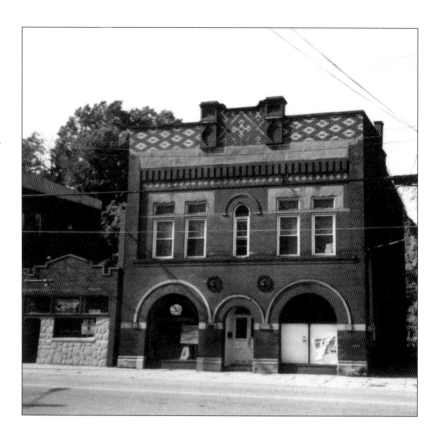

BRIDGE STREET FIRE STATION TODAY. The building no longer serves that function, but it has been wonderfully preserved. (Borsvold Collection.)

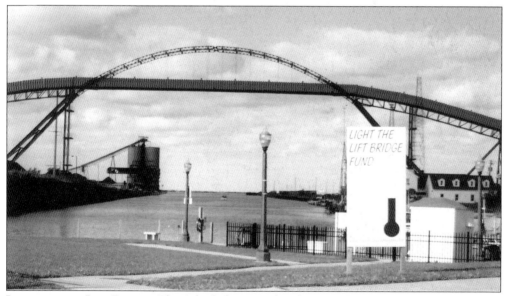

LIGHTING THE LIFT BRIDGE. The Ashtabula Area Chamber Foundation, led by a group of private citizens, is collecting money for a special project to light the Lift Bridge in blue at night as a tourist landmark. The work will begin upon completion of fundraising, and the Ohio Department of Transportation will carry the cost of keeping the bridge lit. (Borsvold Collection.)

125

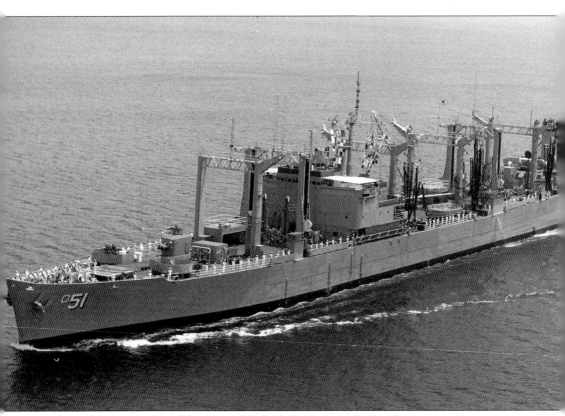

THE USS *ASHTABULA*. (Courtesy of Ashtabula Marine Museum.)

Five

A Ship Named Ashtabula

The USS *Ashtabula*, a steam-turbine fleet oiler, served with distinction in two wars. A fleet oiler's mission was to transport bulk petroleum and lubricants and refuel ships underway at sea. The *Ashtabula* (AO 51) was built in Sparrows Point, Maryland, launched on May 22, 1943, and commissioned on August 7 of that year. She received five battle stars for her service in the Pacific during World War II and four more in Korean War action.

At 553 feet in length and with a displacement of 7,470 tons, the *Ashtabula* cruised at 18 knots. Over the years a handful of men from the city of Ashtabula served among her complement of 19 officers and 284 enlisted men. She was decommissioned on September 30, 1982. The saltwater ship never called at her namesake city, but after she was stricken from the Naval Vessels Register in 1991, her captain helicoptered into Ashtabula to deliver artifacts to the Ashtabula Marine Museum. The Navy, however, had one last role for her to play. Pulled off the scrap line in 1999, she was set up for target practice on October 14, 2000.

The *Ashtabula*, surrounded by seven U.S., British, and French ships, put on an astounding show of durability, taking 8 Harpoon missiles, 2 SM-2s, 3 Sea Skua missiles, 4 bombs from S-3 Vikings, and over 100 rounds of gunfire from 3", 100mm, and 5" guns. A penetration warhead detonated inside the ship but failed to open her hull. She was finally sunk by demolition charges.

BIBLIOGRAPHY

Ashtabula County Genealogical Society. *Ashtabula County History, Then and Now.* Dallas: Taylor Publishing, 1985.

Beaver, Roy. *The Bessemer and Lake Erie Railroad, 1869–1969.* San Marino, California: Golden West Books, 1969.

Clark, Rev. Rufus. *Early History of the South Ridge.* Centennial reprint edition: Ashtabula County Genealogical Society, undated.

Harwood, Herbert Jr. *Summer Frenzy on Lake Erie: Moving Coal and Ore in the 1950s.* Classic Trains, Summer 2000.

Hilton, George W. *The Great Lakes Car Ferries.* Berkeley: Howell-North, 1962.

Hirsimaki, Eric. *Hulett Iron-Ore Unloaders: Historic Engineering Landmark.* Cleveland: American Society of Mechanical Engineers, August 1998 brochure.

Oleszewski, Wes. *Keepers of Valor, Lakes of Vengeance: Lakeboats, Lifesavers and Lighthouses.* Gwinn, Michigan: Avery Color Studios, 2000.

Peet, Rev. Stephen D. *The Ashtabula Disaster.* Chicago: J.S. Goodman - Louis Lloyd & Co., 1877. Centennial reprint edition: Evansville, IN: Unigraphic, Inc., 1976.

Plowden, David. *End of an Era: The Last of the Great Lakes Steamboats.* New York: W.W. Norton and Company, 1992.

Thompson, Mark L. *Graveyard of the Lakes.* Detroit: Wayne State University Press, 2000.

Williams, William F. *History of Ashtabula County, Ohio.* Philadelphia: Williams Brothers, 1878.